Also Known As

Also Known As

Uncovering Representational Frameworks in Architecture, Art, and Digital Media

Michelle JaJa Chang

Afterword by Jesús Vassallo

**The MIT Press
Cambridge, Massachusetts
London, England**

Contents

12	**Hat to Home**
32	**Slipstream**
54	**Something Vague**
80	**Noise**
108	**Shadows and Other Things**
132	**Down the Loss Landscape**
158	**Notes**
164	**Afterword by Jesús Vassallo**
174	**Acknowledgments**

Hat to Home

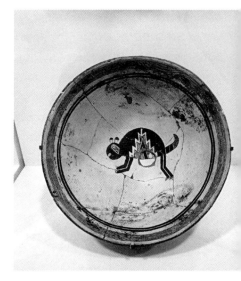

Fig. 1
Unknown artist, *Bowl with Badger*,
1000–1150. Photograph by the author, 2015.

In an area too narrow to be a room and too full of art to be a corridor rest several decorated bowls. The Museum of Fine Arts in Houston (MFAH), a mostly aboveground campus, houses the space (and the bowls) in an underground passage linking the Audrey Jones Beck Building, designed by Rafael Moneo, and the Caroline Wiess Law Building, designed by Ludwig Mies van der Rohe. "LL4 Native American Art of the Southwest," as the area is labeled on the MFAH map, connects a stair and landing ("LL5 Photographs and Works on Paper") and a tunnel ("LL2 The Light Inside by James Turrell"). We could call it a gallery in the geological or the militaristic sense, but less convincingly so by everyday architectural standards. How the artifacts ended up in such an ancillary part of the museum is unclear, but one can hope that the curators had the bowls' original function in mind.

 The shallow vessels are striking in their abstract graphics and figurative symbolism: two-tone decorations—black and white or red and white—in a combination of hatched lines, polygons, spirals, and animals are painted only on the inside (such that the simple act of flipping the bowl over conceals its adornment). Walking by, one might not see that all the vessels are pierced. A coin-sized hole lies at the base of each bowl, interrupting the painted design. To hide the holes, conservators have plugged them with bits of clay colored to match the original patterns. But to anyone staring at the bowls directly, their damage is obvious. Why are they broken in the first place, and why are they fixed?

 From 900 to 1000 CE, in what is today southwestern New Mexico, practitioners of the Mimbres mortuary culture turned from cremation and other outdoor funerals to subterranean rituals, burying the dead in deep pits beneath houses and covering their heads with bowls. An evolution in these practices paralleled a shift in domestic architecture: homes

once designed to be entered at grade began to exhibit ceiling hatches, requiring inhabitants to walk onto convex roofs and down ladders to go inside. A typical pit house was contained in a single room between a sunken floor and a ceiling, which appeared as a convex latticework of post-and-beam members. Archaeological sections through houses of this era and the graves below them reveal not one but two curved profiles: the large dome of the mud roof and the small dome of the overturned ceramic bowl buried underground. It is as though one dome is offset from the other, each forming, in its own way, a barrier between the house's occupants and the sky.

That the building and the vessel came to resemble each other is no coincidence; both were symbols for spiritual emergence in the Mimbres universe, which comprised an underworld, middle world, and upper world. The bowl can be seen as a diagram for architecture in two senses. Empirically, one can observe the smooth clay exterior and painted graphics' relation of parts echoed in the roof's tectonics. No prior knowledge is necessary to sense their material resemblance. Discursively, one can follow piercing as a means to translate figurative into literal ascension. Its meaning and its ability to perform comes from understanding the history of perforated domes. For architectural historian K. Michael Hays, diagrams carry both immediate, intuited effects and enduring effects that arise from an understanding of their associations between the past and future.[1]

Mimbres bowls supported everyday tasks, like eating and carrying, before assuming their ceremonial function. Only then did a family member turn the vessel upside down and bore a hole through its center, repurposing it as a tool for transcendence. In death, their painted surfaces continued to face their users, like a screen displaying the mundane realm.

The reasons for piercing the bowls are debated; while perhaps simply to make the pots dysfunctional as dinnerware, a popular theory is that the act releases the spirits of both the bowl's artisan and the buried. Like pre-900 CE pit houses, intact bowls obstruct the sky. Breaking the pottery facilitates a kind of catharsis akin to "killing" plates in Greek ceremonies. A material loss mirrors an emotional loss.

The fact that the MFAH bowls were once killed makes their reconstitution as a dish curious. In a way, filling their holes both reveals and annuls their ritual function. Perhaps the subterranean gallery next to the Turrell installation, though bearing little resemblance to the artifacts it holds, now serves as a portal from underground to light.

●

With enough patience, you can purchase Mimbres sherds on eBay for less than fifty dollars. The fragments take about a week to arrive and come in a small plastic baggie, a presentation that seems at once unceremonious and illicit. There is no guarantee that the pieces will fit together, which is incentive enough to keep purchasing. Given sufficient time for probing, you can hold a relic that once helped carry someone to the afterlife on the cheap. What drives eBayers to purchase pottery sherds is the possibility of privately reconstructing history, of becoming an everyday archaeologist, however much these small-scale antiquities trades run counter to the sanctity of a past event.

An impulse toward forensic poetics is seen, too, in the conservator. The bowls in LL4 look intact from a distance because fragments have been fashioned to camouflage their fracture. Someone took great care to mold small pieces of clay to fill the irregularly shaped voids. They took time

to paint the plugs with interpolated colors and figures. A modern horror vacui contravenes the reasons the bowls were broken in the first place, so the insertion is odd. Of all the reasons that the MFAH might have to camouflage the breakage, ignorance of the object's history is one of the least likely. The reconstruction could have occurred for didactic purposes, to stimulate the audience's imagination, to show what could have been, or possibly to recover some agency for the object. If breaking releases the bowl and its artisan from their attachments to the buried, then perhaps mending binds the conservator to the dead.

These acts of retrieval are compelled by the pleasures of investigation. It is the allure of the almost complete—cliffhangers, seventh chords, last bites, last swipes (just one more, and I'll be done)—that keeps us surveying. Such desire, the writer and filmmaker Alain Robbe-Grillet writes, is sustained by *difficulty*: "The knot of A . . .'s hair, seen at such close range from behind, seems to be extremely complicated. It is difficult to follow the convolutions of different strands: several solutions seem possible at some places, and in others, none."[2] In Robbe-Grillet's 1957 novel *Jealousy*, a narrating husband searches for traces of infidelity on his spouse's body, as if he can find truth as to whether she is cheating through repeated examinations of the back of her head. The protagonist is bound by his impulse to solve—to untie or loosen—a relationship status that is as open ended as the twists in his wife's curls. The object is difficult not in its technique (hair is easily braided), nor in its scarcity (hair is everywhere), but in its illegibility (hair is convoluted).

Readings (and re-readings) are elicited by spontaneous part-to-whole relations that evade definition. We are constantly thrown off by rabbit holes of fascination and a

gripping faith in the possibility of resolution. Difficult-to-read, or simply illegible, objects build anticipation by thwarting successful interpretations, rendering many possible but ultimately incomplete perspectives. This differs from the multiple readings prompted by ambiguity in sentences (late-night texts from exes), images (rabbit-duck illusions), and things (postmodern buildings), whose difficulty arises from reconciling delivered meanings.[3] Inscrutable sentences (gibberish), images (noise), and things (monoliths) differ still, as they lack discernible parts from which to draw any meaning.

Why bother with illegible things given such little promise for satisfaction? Grappling with them leaves us at the very least confused and at worst defeated, seated facing a broken bowl. Yet through obstruction, they also furnish opportunities to form enduring attachments between people and things.

In the 1990s, the anthropologist Alfred Gell theorized that decorated artforms act as social mediators when they are mentally fixating, or "tacky." In his 1998 book *Art and Agency*, he proposes that one's attraction to patterned artifacts cannot be wholly attributed to aesthetics or meaning but rather to the "pleasurable frustration" of trying to figure out the organization of their motifs.[4] For Gell, a complex arrangement of shapes is like a difficult text; both invite line-by-line interpretations. Celtic knotwork, for example, is believed to arrest evil spirits as they attempt to unravel its braids, turning ordinary materials like stone into sources of persistent wonder. This effect arises not from the object itself but from the effort of envisioning how something was created—what he calls a "symbolic process."[5] Decorated objects stoke fantasies about the contexts that surrounded their production, prolonging relationships between their

viewers and their makers. It is for similar reasons that the practitioners of the Mimbres culture believed that only material ruin could free the spirits of the dead and the bowl's maker.

The difficulty of not knowing how something came to be is a type of ontological friction that arises when one's concepts about making are incommensurable with what is shown by something real. Fixing pottery may be a familiar task, but one cannot anticipate the labor and time involved in repairing ancient remains. Technological processes—like braiding, breaking, or mending—transform things such that their parts cannot be traced to their original states. Yet *some* procedural legibility nevertheless persists, drawing attention to the manner of the thing's construction. Convolution both encourages and resists manufacture. This contradiction lies at the crux of an illegible object's function: to suspend spectators in a contemplative space. Instead of invoking transcendence, it keeps people in the sometimes tedious, sometimes satisfying ordinary world.

Illegible objects do not make copying easy, but perhaps that's the point. In the way that encryption thwarts counterfeiting, their difficulty delays, or even halts, reproduction. Still, we can glean something from them. In its repaired state, a Mimbres bowl can serve as an architectural diagram, not as a symbolic portal as it did in ancient Mimbres culture, but as a mental trap. The artifact now belongs in a category of objects with eBay transactions and infinite-scrolling apps, whose difficulty lies in their totalities being just beyond our grasp. Their illegibility can be immediately sensed by the appearance of a convoluted technology (empirically diagrammatic) yet also understood through a set of historically linked practices like solving crimes (discursively diagrammatic). To recreate their effects, one

might opt for a formal approach—rather than the purely visual approach of Gell's symbolic process—that asks us to consider how part-to-whole relations emerge from socially encoded patterns.

 To replicate in this way raises questions like, What if we were to devote as much attention to a gallery as we do to the artifacts exhibited within it? How might the room's design engender a similar fascination? Clues for such a performance already exist in the objects that it holds. Perhaps, then, LL4 would be more difficult to pass through. If the gallery were to become more like the bowls, it would mean that it, too, could be looked at closely and over time.

UltraTouch Natural Cottonfiber Insulation Denim Blue
48" L × 16" W × 2"

Void Filling/Marine Insulating Spray Foam Insulation Kit, 37.8 lb. Two Cylinders, Cream

Twisted Nylon Cord, Blue
1.5mm × 328'

Netting Mesh
4' W × 250' L × 1/4"

Cartman Lashing Straps,
1.5mm × 328'

Premium Kiln-Dried Whitewood Stud
1.5" × 3.5" × 96"

Insulation Cup Head Washer,
12 Ga. 3", 200 per lot

Knauf Earthwood Mineral wool Heat insulation
23" L × 17" W × 2" T

Surge protective receptacle and 20 Amp Industrial Grade Heavy Duty Toggle Switch

Heavy Duty Polyester Cord Strapping
3/4" × 2,500'

Bluewood, pressure-treated, LEED rated "Green"

Plastic Cap Nail
Grip-Rite 1"

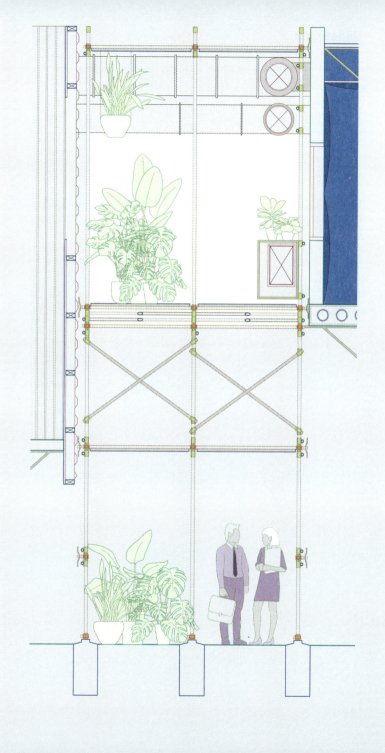

Slipstream

If you make it all the way to Marfa, Texas, to see art—a three-hour drive from the nearest commercial airports or, for me and three other architects in 2017, a nine-hour drive from Houston—you are likely to visit Valentine too. From Marfa to Valentine there is not much to see, except the landscape itself. A tan combination of dried grasses and dirt shapes a constant horizon against the sky. The thirty-five-mile stretch of US 90 between the Chinati Foundation and Elmgreen & Dragset's Prada Marfa sculpture appears less like an interstate highway than a shaved patch on a merle coat. On the way to Prada, we caught a glimpse of a large flying object that resembled the plastic fish that babies play with in the bathtub. We decided that the object (was it art?) deserved a detour, but a half mile away we were stopped by a broken-down fence with two signs: "WARNING; CONTROLLED AREA; While on this installation all personnel and the property under their control are subject to search" and "Tethered Aerostat Radar System; U.S. Customs and Border Protection."

 The object was decidedly not art. The Tethered Aerostat Radar System (TARS) is one of eight surveillance blimps positioned along the US-Mexico border and the Florida Straits.[6] While the blimps' mere presence acts as a deterrent to migrants traveling on foot, their primary function is to stop illegal drug trafficking by plane. Each balloon contains a 2,200-pound radar for detecting low-flying aircraft activity over a 200-mile range. When weather conditions are favorable—with not too much wind—US Customs and Border Protection (CBP) deploys these "eyes in the sky" ten thousand feet up, a height about the length of the National Mall. Long bridles hold the aircraft to the ground like reverse marionettes while they gather data wirelessly. By 1991, CBP had finished installing its blimps along the border, casting a

200- by 1,954-mile virtual canopy from the sky. Like the Prada Marfa sculpture, which turns a long strip of otherwise unoccupied roadway into a tourist destination, the blimps give shape to a previously undefined zone.

Three years after CBP finished installing the blimps, Fredric Jameson in his book *The Seeds of Time* described the dissolving of public and private space—a blurring propelled by (late) capitalist development and the erosion of civil society—as occasioning the formation of a new collective environment, one that would no longer be defined in binary terms.[7] He called it the "no-man's-land." Rather than cede all traces of the binary to a shapeless condition, Jameson projected the possibility of an interstitial zone. This was an extrapublic, extraprivate space that stood outside the law and as such, created space for new performances. An underground meeting place beneath the Berlin Wall from a John le Carré spy novel served as one example. In these spaces "the very freedom from state terror lends the violence of the no-man's-land the value of a distinctive kind of praxis, excitement rather than fear—the space of adventure that replaces the old medieval landscape of romance with a fully built and posturban infinite space."[8] If we take the lost distinction between public and private as a thoroughgoing condition, Jameson's provocation suggests that the no man's land emerges as a totality rather than a glitch.

Jameson's literary reference to no man's lands spurs fantasies of autonomous realms, but are there any cases of such spaces in our midst? Consider the fire escapes added to New York City tenements in the late 1800s in response to a series of deadly fires. These filled an indisputable need when buildings were constructed of mostly combustible materials, but their iron and steel skeletons have since begun to rust, and their steep inclines are deemed too dangerous

to provide emergency escape. Today's building codes have pushed egress back inside, requiring internal exit stairs made of fire-rated materials like concrete and steel. While fire escapes are no longer permitted in new construction, we still see steep metal ladders adorning thousands of facades in New York City. Buildings can now carry both old and new means of egress, making fire escapes legally ambiguous, and possibly no man's lands. Between varying rhythms in code and construction cycles, the time of fire escapes is, so to speak, out of sync.[9]

 The continued presence of fire escapes does more than reflect evolving ideas about building safety; it also demonstrates what occupying a no man's land can do for a city. Under the cover of verticality, the occupant is afforded temporary discreetness similar to the experience of being in a crowd. Fire escapes invite New Yorkers to construct a program for the precarious space. Romantic dinners, drunken fights, smoking (cigarettes or meats)—all are distinct performances ill fit for both the domestic realm and the street. Patio furniture, mini charcoal grills, and other trimmings pack onto the three-foot ledge, an odd mix of belongings that leave traces of changing neighborhood activity.

 Though fire escapes create areas neither inside nor outside, neither public nor private, they do not exhibit the political urgency evoked by Jameson's writing. For more exacting examples, we must look at the government's approach to surveillance.

●

The US Department of Homeland Security (DHS) understands the problem of the no man's land well. It is in their interest to eliminate it. DHS operations on the ground surveil

the space on either side of the US-Mexico border, as far as a patrol officer can see. A fleet of white and Kelly-green trucks traces the boundary, as though drawing a line in the sand, to physically detain and visually deter migrants. Above the trucks, the TARS program casts its network of radars. According to a 2019 DHS congressional report, "The attacks of September 11th and the continuing lethality of our adversaries exacerbate the gap between the air surveillance that the Nation has and the air surveillance that the Nation requires. For DHS, this is particularly acute in lower altitude airspace in the border regions."[10] The technical term for the gap described here is "radar shadow." Radar operates similarly to light projection in that hidden areas are created by matter occluding wave transmissions. Ground signals cast shadows behind topography that are tangent to the earth's curvature, creating opportunities for planes to fly "under the radar." The military introduced TARS to eliminate formerly dark regions, much in the way that light boxes bring out details in model photography.

For patrol officers, combing the sky is impractical; they need other ways to describe air. In his book *Terror from the Air*, Peter Sloterdijk explains how air was given material presence with the introduction of chemical weapons during World War I.[11] Whereas classical warfare struck bodies, settlements, and fortifications, modern warfare attacks the environment. The TARS program adopts this modern approach but solidifies the air once rendered by toxic gases into conspicuous white objects. The eight surveillance blimps draw out and colonize the vertical space above the US-Mexico border, erecting a ten-thousand-foot wall of radar visibility out of thin air.

Like today's fire escapes, radar shadow is brought about by the failure of systems that separate zones of legal/

illegal, inside/outside. When TARS crashes, the area around the US-Mexico border does not return to a formerly free territory. Nor does it maintain national sovereignty because it is not policed. Instead, a space develops where its occupants are shaped by a new whole rather than by otherness.

Can studying a government strategy for undoing the no man's land help us construct one? During World War I, the No Man's Land was a space between enemy trenches that marked each army's outer bounds. Opposing forces were delineated not by a single line but rather by an unoccupied remainder. Unlike with Jameson's example, it is not necessary to go underground to find a no man's land.

This was made obvious on February 14, 2012. According to a report by the US Air Force (USAF) Aircraft Accident Investigation Board for that day, the misinterpretation of a call as a canceled wind alert, rather than an elevated warning, set off a chain of events that resulted in a blimp's destruction and $8.8 million in damage.[12] A sudden change in weather near Valentine, Texas, led to an unexpected event: a 186-foot blimp snapped from its tether and careened a hundred yards before taking a nosedive into a cattle field. (Climate records show that a gust of wind, between six and seven on the Beaufort Wind Scale, blew through the area in midafternoon. A six on the zero-to-twelve scale presents as "large branches in motion; whistling heard in telegraph wires; umbrellas used with difficulty," and a seven as "whole trees in motion; inconvenience felt when walking against the wind." For a moment, the government's surveillance apparatus was discontinuous. An hour prior, the air was at zero, or "calm; smoke rises vertically.")

The crash triggered a visit from the president of the USAF Aircraft Accident Investigation Board, Scott S. Cole, who found that the incident was the result of human error.

To evaluate the incident, Cole used the Department of Defense's (DoD) Human Factors Analysis and Classification System (HFACS), a framework that articulates over a hundred definitions for "error" and "mishap" for various scenarios where things could go wrong. Eleven factors caused the Valentine's Day "mishap," including error due to misperception (Perception Error AE301), misperception of operation conditions (Perceptual Factor PC504), and misinterpreted/misread instrument (Perceptual Factor PC505). The eighteen classifications for misjudgment and misperception aside, the mishap might otherwise be interpreted as just that: a random event. But when the TARS blimp crashed near Marfa in February 2012, a no man's land arose from an accident and a well-defined space for error.

 The south Texas sky presents multiple openings for no man's lands. For one, the airspace between a cloud and the stretch of land along the border can temporarily exist outside CBP's detection. Its lawlessness grows less from a lack of description than from an excess of it. For increasing specificity in defining error does not eradicate it. Instead, specificity produces error as a well-defined zone. The HFACS and the absence of TARS blimps give us a clear picture of error. When instruments producing the surveilled environment—Doppler, cameras, ground control—multiply and get out of sync, deviating paths are unlocked. Given that CBP is a law-enforcement body, any gaps in its radar wall can become no man's lands. It is worth noting that these no man's lands do not arise prior to their description as surveilled zones. Radar is a precondition for radar shadow, just as the sun must exist before objects can cast shade. Though a formerly surveilled area is technically called a "shadow," it can be reframed as a "slipstream," an air current that follows a moving object. The current eases travel for

other objects, as seen in competitive racing, where slipstreaming, or drafting, allows athletes to move more efficiently through an area of lower wind resistance. In this way, the no man's land presents opportunity rather than obfuscation.

Occasions for constructing no man's lands are already embedded within architectural practice in the United States. Like the strategies adopted by DHS, CBP, and DoD, protocols guiding the architectural profession are detailed, time dependent, and state authorized. They are also prone to slips. US building and zoning codes are works of prescription that seek to exact normative architectural performance. Relative to other codes like the UK's Building Regulations, they are also highly detailed. Their specificity, which increases every year, multiplies possibilities for no man's lands, such as New York's fire escapes. For architects, finding gaps in code language is as common as marking up drawings for revision. Can we mobilize these skills toward a design practice of slipstreaming?

Consider the category *single-family residence*. State and local governments regulate a property's use with zoning laws, dividing cities into coarse categories such as residential, commercial, and industrial and finer subcategories such as single-family, office, and manufacturing. Each use category limits the kinds of buildings and occupants permitted on a lot. Laws for single-family-residence districts, for example, promote detached houses by requiring structures to be set back from the street and neighboring lots. They also describe the number of occupants and the kinds of social relationships they may have. In Chesapeake, Virginia, a "family" can consist of no more than two adults and up to three blood-related or adopted minors, but any number of "domestic servants" can live on the premises without being

counted as family. As such, a house in Chesapeake that is home to more than two unrelated adults is legally not a residence.

States and local governments enforce a separate body of building codes to authorize the design and construction of buildings. Since each state can adopt the International Building Code (IBC) or the International Residential Code (IRC), use its own codes, and give local governments the power to enact codes more stringent than those of the state, there are varying levels at which terms are specified. "Single-family residence" may be defined by how many rooms belong in a house, what kinds of rooms, what kinds of materials, and what kinds of residents. Though it describes "single-family residence" extensively, the IBC and IRC omit "family" from their definitions. For such missing definitions, the IBC furnishes a general category—"201.4 Terms not defined"—and defers to the "ordinarily accepted meanings such as the context implies." The fact that general interpretations can coexist with highly specific requirements in building codes and zoning laws suggests opportunities for no man's lands. The appearance of the word "family" in legal definitions of the built environment is one of them.

At the time of this writing (winter 2021), Chesapeake building regulations still define a family as two adults and up to three blood-related or adopted minors. But an unforeseen event has shifted domestic space on a national level. The COVID-19 pandemic spurred various modes of dwelling: apartment rentals by individuals for indeterminate durations (illegal as single-family residences when the owner is absent), accessory dwelling unit (ADU) rentals occupied by unrelated families (illegal in some states), and house rentals shared by several coworkers (illegal as a single-family residence when the owner is absent and without a lease).

A host of arrangements that defy regulations flourished and persist simply because the pandemic was unexpected. Were we to take up one of these scenarios—the illegal yet tolerated ADU rentals, for example—as a housing type to keep building, its model of family will persist in the world long after the virus subsides.

 Whether by design or by accident, no man's lands form in the absence of a totalizing and perfectly synchronized representation of the world. The various cadences of code updates—the IBC (triennially), state and local regulations (annually), LEED guides (quarterly), zoning amendments and unexpected measures (intermittently)—and the many contradictions their contents contain grant us opportunities. But to use them, we must change how we work. Slipstreaming requires a deep understanding of how the mechanisms that control visible and temporal space function, as well as an ability to find holes in them. It points to the fringes of our systemically controlled environments, encouraging us to find "excitement rather than fear" and the unknown pleasures of the no man's land. Following an update in fire codes, a vertical space created by fire escapes changed the character of New York City streets; right after the Valentine's Day TARS crash, a two-hundred-mile area of sky functioned more like a portal than a wall; and during a global pandemic, a collection of houses presented new models for family life. Probing everyday practices turns our search for no man's lands away from utopian visions. Working with laws moves us away from anarchy. Architects can engage these gaps as slipstreams, so as not to go underground but to live outside the law in plain sight.

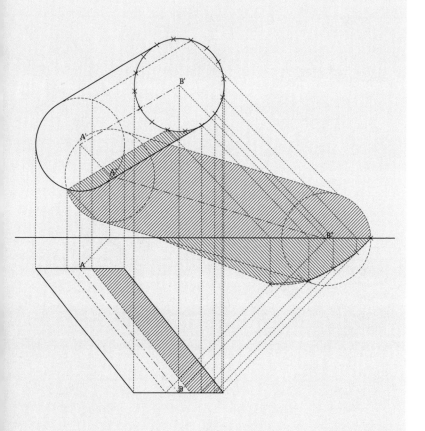

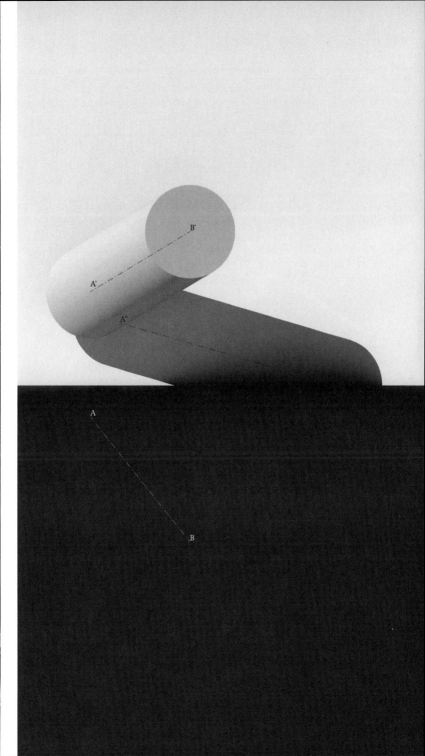

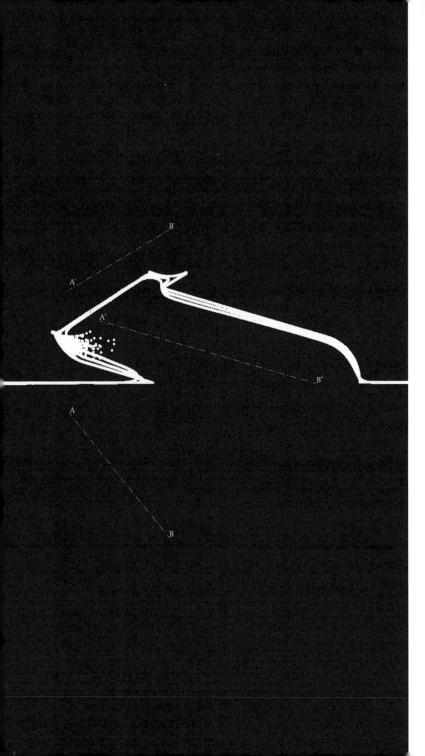

PANEL 04

Something Vague

The Vanna Venturi House is a vaguely gray building. A simple Google or Instagram search produces several color photos of its exterior, which appears in varying tones of what one could call gray. A visit to the building, depending on the season or time of day, reveals similar gray-like colors. In a 2006 interview, Denise Scott Brown and Robert Venturi recounted how the color of the house was selected.[13] The original choice was "warm gray"—a hue that both Venturi and his mother liked. But after coming across Marcel Breuer's advice to avoid green as a house color, Venturi said he painted over the gray with a shade of green. Over the years, as the architects' ongoing desires to break modernists' rules were tempered by aesthetic preference, the house was repainted more like its original color. Even though the house was sometimes perceived as "more gray," the architects conceived of it as green. Thus one can say the house is not definitely gray because its hue lies somewhere between gray and green.

The uncertainty surrounding any building's color emphasizes a fundamental indeterminacy in communicating architectural qualities, such as tall proportions or round forms. To borrow from the philosopher Nelson Goodman, a quality is "a class of things that resemble each other."[14] Goodman's definition makes the description of architectural qualities an interesting problem because of the difficulty of classifying things based on perceptions of their commonalities. People disagree about the precise meanings of words and images, and in linguistics and philosophy this discrepancy is known as *vagueness*. While there are several contested theories of vagueness in these fields, the criteria developed by the philosopher Rosanna Keefe are productive for architecture. Competing theories, such as Terence Parsons's view that things are inherently vague or Timothy

Williamson's position that vagueness arises from unavoidable ignorance, give architects no opportunities to instrumentalize vagueness as they act on the world. For Keefe, vagueness arises from language, and something is vague when it demonstrates three characteristics: it is a borderline case, it has a fuzzy boundary, and it exhibits the sorites paradox.[15]

The first characteristic, a borderline case, is a marginal condition within a category. For Keefe, these are instances where it is uncertain whether a category, like a color, applies. Take the color burgundy. Because it lies at the edge of the red spectrum, it is not clearly true or false whether burgundy belongs to the class of reds. The color is a borderline case, not for its own lack of specificity but because the limits of redness are indefinite. Adding new information, like a hexadecimal code, does not determine whether burgundy is red or not red.

The second characteristic, a fuzzy boundary, is an ill-defined border between groups. Similar to a borderline case, it too relates to an edge condition. In Keefe's example, there is no sharp boundary dividing tall and not tall people, for the quality of tallness has a region of borderline cases. A grouping of tall people has a fuzzy boundary that shifts according to the method used to assess a person's height. Whether a person is tall cannot be decided by binary definitions—tall or not tall—because inconsistencies in measurement systems cast doubt on definitive judgments. Classifying architecture according to tallness creates similar uncertainties. For instance, the category of high-rise buildings has a fuzzy boundary because it is defined differently in different building codes. By Japanese standards, a high-rise is a building taller than 102 feet (31 meters), but according to the 2015 International Building Code, a

high-rise building is one that has an occupiable floor more than 75 feet (22.86 meters) above a fire access road.[16] There are borderline cases, like Kazuyo Sejima's 98-foot- (30-meter-) tall Shibaura House, because there is no absolute line between high-rise building and not-high-rise building. Categories with fuzzy boundaries, or fringes, are best described by gradients because they cannot be drawn with hard edges.

The third characteristic, the sorites paradox, encompasses both borderline cases and fuzzy boundaries. Attributed to the ancient Greek logician Eubulides of Miletus, the sorites paradox problematizes the limit of a heap to describe the term's indefinite qualities. The paradox starts with two statements that we know a priori to be true: (1) one million grains of sand make a heap and (2) one grain of sand does not make a heap. We are sure that the heap of one million grains of sand is still a heap after removing one grain or two or three. By reduction ad infinitum, the remaining grain of sand is still a heap, thus paradoxically contradicting the second statement. Finding the exact number of grains at which a heap becomes a nonheap is impossible, not for lack of measurement, but because the word "heap" is imprecise. It is this fundamental imprecision of language that makes "heap" and words like "small," "tall," and "gray" vague.

Following Keefe's criteria, the Vanna Venturi House is categorically a vaguely gray building. But categorizing buildings as gray, or as any color, cannot be done with any certainty because there are conflicting color models. Attempting to color-match the Vanna Venturi House exterior leads to results such as Benjamin Moore Paints' Gray Wisp (CC-670) and Sherwin-Williams's Unusual Gray (SW 7059). Finding where gray ends even within a given paint measurement system is impossible when one considers seasonal

variations in light or the discrepancies between printed fan decks and digital palettes.

Classifying buildings according to their apparent qualities frequently creates groups with fuzzy boundaries, for the extent of a set is indefinite when there are several competing descriptive methods. The gradients between gray/not gray, small/not small, and tall/not tall are similar to the elasticity of fuzzy sets found in mathematics. Developed by the mathematician Lotfi Zadeh in the mid-1960s, fuzzy-set theory proposes that there is a gradual shift from an object's membership to its nonmembership in a set.[17] The boundaries of a fuzzy set can expand or contract, making the border that establishes an object's membership indefinite. Classical sets, on the other hand, have fixed divisions such that an object's membership is exact and definite. Mathematically, classical sets use ones and zeroes to mark whether membership is true or false, while fuzzy sets use fractions that range from 0 to 1. These fractional numbers, known as the "grades of membership," measure the alignment between conceptual and perceptual definitions. For instance, a basketball has a high grade of membership (close to one) in the category of spheres because its appearance aligns with our geometric understanding of sphericity. To fit our perception of the object into our conception of the category requires minimal mental gymnastics. However, putting Boullée's cenotaph for Isaac Newton in the category of spheres may require some imagination, since its central void resembles a sphere, but its exterior form does not. The cenotaph meets the standard definition of sphericity less obviously, thus its grade of membership is closer to zero.

In fuzzy sets, the grade of membership is the inverse of the degree of mental compensation required to stretch our conception of a category to include a given thing. This

conceptual stretch, what Zadeh calls "elasticity," is not a measurement of probability because it is not mathematically deduced. Rather, grades of membership are subjective values that indicate the distance from norms. The Vanna Venturi House does not completely conform to normal color descriptions of gray today, but it is possibly gray when the building's history and the perceptual limits of color are considered.

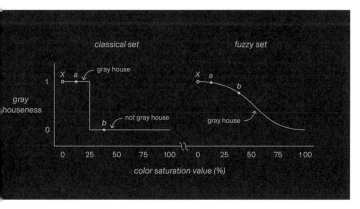

Fig. 2
A fuzzy set of gray houses (X) comprises the Davis Studio and Residence, the Bjornson House, the Villa Snellman, the Upper Lawn Pavilion, and the Koshino House and can include the Machiya in Daita (a) and the Vanna Venturi House (b) because the boundary between gray house and not gray house is measured with grades of membership instead of binary values.

The vagueness associated with fuzzy sets is useful for categorizing architecture because it involves an indefinite set whose boundaries are imprecise, rather than a definite set of references. Consider, for example, a category of gray houses that includes Frank Gehry's Davis Studio and Residence, Arata Isozaki's Bjornson House, Gunnar Asplund's Villa Snellman, Alison and Peter Smithson's Upper Lawn

Pavilion, and Tadao Ando's Koshino House. To include the Vanna Venturi House in this set would be more of a stretch than including, say, Kazunari Sakamoto's Machiya House in Daita because Sakamoto's silver facade appears more conventionally gray than Venturi's gray-green one. But in a fuzzy set, the boundary limiting what constitutes a category is imprecise, so any grouping of gray houses can be pushed beyond perceptual norms. By extension, one could include a greenish building in a group of gray houses.

The value of vagueness for architecture lies in the possibility of redefining a category by including or excluding the things that belong in it. Including a house that would conventionally be considered not-gray in a category of gray houses brings a new type of gray house into existence. Similarly, vague thinking is a creative act that reframes categories by applying granularity to words and concepts, furnishing them with new meanings.

●

Vagueness can be particularly instrumental in today's regime of architectural image-making. The way architects have traditionally used drawings to think about form and space is incompatible with the medium of digital images. When architectural production shifted toward Photoshop, V-Ray, and other raster-imaging programs, vagueness became increasingly relevant as a design tool. Unlike drawings, raster images can vary in resolution because they are pixelized, ranging in fineness from low resolution (low pixel number per inch) to high resolution (high pixel number per inch). Resolution presents an interesting set of form-finding problems because the limits of a given object become more complex when there are more pixels to sort.

Architectural production has historically been dominated by a kind of technical drawing that seeks to eliminate vagueness. In constructed drawings, which follow the rules of Renaissance perspective and parallel projection, linearity creates clear distinctions between objects.

The proliferation of raster images in architectural production today has made vagueness ever present. Though their information structures are far denser than those of drawings, these images actually widen the distance between representation, language, and perception. Ever-higher resolutions increase the possibility for vagueness, and thus the potential for designers to integrate vagueness into architecture in powerful ways.

Like a jigsaw puzzle whose pattern of cuts is independent of the subjects it may depict, a raster image is indifferent to the objects it represents due to a pixel grid.[18] Digital image-processing techniques were therefore developed to analyze how pixels add up to be representations of real things. In the 1970s, the first edge-detection algorithms were developed to problematize finding contours—groups of pixels that represent an edge between depicted objects—in raster images. The algorithms employed several strategies based on differences in brightness, color, and movement to encode images with meaning, thus allowing objects to be manipulated as such. The many algorithms used to select things in Photoshop alone demonstrate not only the theoretical nature of this programming exercise but also the inherent vagueness of image analysis. Form-finding problems like drawing an object's extents using Photoshop's Magic Wand, Magnetic Lasso, or Object Selection tools could thus be said to resemble the sorites paradox, insofar as they are exercises in representing indefinite limits. For example, rasterized to a standard monitor's full resolution of

one million pixels, the data making up figure 3 is a picture of the sky; reduced to a single pixel, it is not a picture of the sky. Blacking out a single pixel or even an edge column of pixels would not compromise the picture of the sky, but the actual number of pixels that constitutes a sky picture and distinguishes it from a not-sky-picture is impossible to define conclusively. The same logic applies to the borders of the clouds. Whether the clouds are a group of pure white pixels, the absence of pure blue pixels, or something in between cannot be objectively resolved. At the same time, designing in a raster medium does allow for some certainty because finding figures and counting parts are bounded by the fringe between absolute conditions.

Fig. 3
Still from *Parallel I* by Harun Farocki. Reprinted with the permission of Harun Farocki GbR. All rights reserved.

Determining how many fine-grained parts constitute a whole can reveal the conceptual definitions that underlie perceived qualities, such as small, tall, and gray. What we might intuitively recognize as an object—a cloud or sky—can be inspected through the technical lens of raster imagery and the conceptual framework of vagueness to reconfigure

qualitative definitions and aesthetic judgments. This requires focusing on fringe conditions, not unlike the way borderline cases within categories such as small, tall, or gray can associate familiar qualities with indeterminate forms.

Despite the prominence of these vague terms in architectural discourse and pedagogy, we as a discipline lack the means to collectively evaluate them. Raster imagery is better equipped than drawing to study vague qualities because its granularity makes possible an examination of the blurred edges between form and its effects or between an effect and its corresponding form. Robin Evans highlighted this problem of description: "Not all things architectural . . . can be arrived at through drawing. There must also be a penumbra of qualities that might only be seen darkly and with great difficulty through it. If judgement is that these qualities in and around the shadow line are more interesting than those laid forth clearly in drawing, then such drawing should be abandoned, and another way of working instituted."[19] But for raster imagery to become more than a technique, for its vagueness to be productive for architectural design, it must support a way of thinking that is unavailable through other media.

●

In his 1923 article "Vagueness," Bertrand Russell compares the vagueness of knowledge to visual representation. "A representation is *vague*," he writes, "when the relation of the representing system to the represented system is not one-one, but one-many."[20] In his example, a smudged photograph of a man is vague because his appearance is indistinguishable from other men. The loss in detail from erasure allows the representation of one person to be

readable as many different people. Russell warns against accepting vagueness as a fundamental quality of things, arguing that it occurs only in their representation. Limitations in visual media and human sight render one's perception of a man vague, but the man himself is not vague. Studying the photograph with a microscope, for example, would perhaps call attention to how the photograph as an object influences how we identify the man, because the cellular view might challenge our initial perception.

Russell's one-one/one-many dichotomy presents a way of thinking with information loss and blur that is incompatible with drawing. Like squinting at city lights, the visual blur experienced when viewing objects is a new way to see something, one that changes how we identify its qualities.[21] Information loss can thus offer a freedom to abstract content in order to work with it anew. To explain how this phenomenon is uniquely suited to the raster medium, we can substitute the degradation of visual data for Russell's notion of a loss of detail.

As a resolution-dependent medium, raster imagery problematizes information loss and blur. This means that the quality of an image varies in inverse relation to the scale at which it is displayed, because the amount of information stored in a raster image is determined by the number of pixels fitting within an image frame. Scaling up a raster image can be accomplished through a process called "interpolation," which multiplies the number of pixels and approximates their values based on patterns in the original image. In Photoshop and other raster-graphics editors, interpolation blurs the image such that its blurriness is a visual index of how much information was lost in the scaling process. Figure 4b of the Vanna Venturi House looks blurry because it is ten times the scale of figure 4a and contains

only 10 percent of the information from the original; the remaining pixels are a product of the interpolation inherent in Photoshop's scaling process. Though the pitch in the elevational profile remains, details such as window casings disappear. Further detail is lost and blurring made more pronounced when the original image is reduced to 5 percent of its initial content (figure 4c) because there are fewer pixels available to inform the new image.

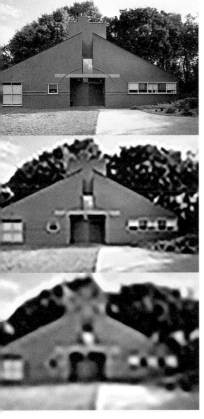

Fig. 4
Robert Venturi, Vanna Venturi House, Philadelphia, 1964. From top: (a) 100 percent scale, (b) 10 percent scale interpolated to full scale, (c) 5 percent scale interpolated to full scale.

Methodologically, image interpolation can be compared to the parametric modeling of topological surfaces found in architecture projects from the early 2000s in that both use averaging techniques to smooth transitions between discrete parts.[22] But the aesthetic effects and conceptual domains created by parametric modeling are very different from those of a vague project and raster imagery. Whereas parametric projects of the past incorporated smoothing to generate form, vagueness uses blurriness as a conceptual tool. Investigating how well the Vanna Venturi House fits into the category of houses by erasing the distinguishing features of its facade does not necessarily lead to the design of a new house by any digital or nondigital means. Employing resolution to probe architectural categories like the house does not mean leveraging processing power toward making what Greg Lynn calls "elegance, rigor, expertise and ... beauty" in tectonic connections, aggregates, or assemblages, because in the parametric project, information is added in the smoothing process.[23] The two projects apply smoothing techniques toward different ends, with opposing relationships to information quantity. Whereas file sizes tend to increase when models are smoothed in a parametric project, they tend to decrease when images are blurred in a vague project. In the 3D modeling software Maya, for example, the Smooth Mesh tool subdivides polygons and increases their mesh count to give the appearance of softness. Increasing this number creates more data to be stored in a Maya file.

While abstraction can be used to respond critically to formal intricacy, in raster imagery it is possible to work with both seemingly opposed concepts at once. That is, articulation in the raster medium can disarticulate the content. In raster images, blurriness makes identifying

content difficult, even though the pictorial structure has the capacity to carry millions of discrete bits of information. The potentials of abstraction found in photographic blurring can, like lens focusing, be carried over to raster imagery simply because pictures can elicit any number of subjects. And pictorial flatness collapses the volumetric qualities that 3D modeling affords, rendering space discontinuous and incomplete.[24]

The imbrication of representation and knowledge is seen in the enduring notion that architectural ideas can be given presence with form. Much like mathematical space was operative for Cartesian dualism and rationalism, drawing was instrumental for developing concepts like ambiguity and indexicality because distinction is well represented by precisely drawn graphics. In architectural drawing, there is a clear difference between drawing (line) and not-drawing (no line), which allows for binary clarity about the shape, proportion, and extent of a drawing's subjects. Historically, such linear representation has continuously supported imaging tasks that require analytical precision.

Vagueness, on the other hand, is a reminder that some forms of representation are hard to define. This phenomenon defies conventional logic insofar as adding information (or pixels) does not bring more clarity. By problematizing the point at what a small house is no longer a small house, the sorites paradox makes us conscious of the limits of the domain of small house. Whereas positivist models of investigation like the scientific method proceed by increasing quantities of information in order to verify hypotheses, fuzzy logic and vague thinking reconfigure existing frameworks that conceptually and perceptually structure an object's existence. Thus knowledge gained from vagueness is less about the object than about the construction of its

definition. What defines the category of small windows, tall facades, or fat proportions cannot be answered with a quantitative approach because the question concerns *how* one judges qualitative values.

Vagueness creates knowledge by adjusting concepts of identity. In *Vagueness and Contradiction*, Roy Sorensen argues that vagueness uncovers the "analytic error" that things belong in discrete categories.[25] He cites the example of two people who disagree about whether pudding is a solid. If they can be convinced that their disagreement is due to the vagueness of the quality, then both will withdraw their original beliefs. In other words, agreement that something is a borderline case makes it impossible to continue believing that it exists in a binary condition. Vague logic "dissolves" analytical disputes and encourages us to reconsider what it means for a quality to be known. Vagueness produces knowledge by adjusting, or even contradicting, a priori classifications and thus clears a space for developing alternatives. If the fact that a certain house is gray no longer holds true because I acknowledge that grayness is a vague quality, then according to Sorensen, the contradiction reveals that what I believed was false.

Setting aside a priori categories such as tall buildings or small houses is not a dumbing down of architectural knowledge. Rather, contesting norms by identifying and examining borderline cases is a creative process that productively engages the fuzziness surrounding physical qualities. As the philosopher William James wrote of vagueness and imagination, "A blurred picture is just as much a single mental fact as a sharp picture is; and the use of either ... require[s] some other modification of consciousness than the mere perception that the picture is distinct or not."[26] For James, making a blurred picture is akin to constructing

a new image, rather than producing an inferior version of a clear image.

Introducing the concept of architectural borderline cases sidesteps binaries and camps—Whites vs. Grays, modernist vs. postmodernist—to uncover new architectures and new ideas. In its lack of distinctness, vague architecture resists classification. Suspending our belief in categorical distinctions means that we, as both designers and viewers, get to inhabit the space of imagination a little longer. This pause makes room for questions such as, Is grayness made of red, green, and blue hues or the absence of light? The value of vagueness as a project, and the value of uncertainty in general, lies in this productive delay. Claiming that the Vanna Venturi House is a vaguely gray building is not an indecisive act. It is a carefully considered position that takes into account the conceptual nature of color and changing perceptions of a building over time. It deliberates over architectural qualities that are constructed as much by technology as by socioeconomic conditions and visual culture. Advocating for the exploration of vagueness in architecture does not suppose a relaxation of judgment; rather, it offers ways to be clear about what is unclear. In designing with vagueness, we take pleasure in tugging at the boundaries surrounding normative distinctions between tall and not tall, small and not small, house and not house—even when those boundaries are gray.

DEEP COLOR

TRUE COLOR

FIG. 1 *CANGIANTE (AS SEEN ON ELEAZAR'S LEG IN MICHELANGELO'S SISTINE CHAPEL FRESCO, 1512)*
In painting the lunette of Eleazar and Matthan, Michelangelo substituted the green shade cast by Eleazar's pants with a reddish hue. The two spheres above show differences between a naturalistic use of color and *cangiante*, the Renaissance painting mode of rendering shadows with artificial colors.

FALSE COLOR

FIG. 2 *FALSE COLOR IMAGING (AS SEEN IN NASA'S INFRARED IMAGES OF THE IMPERIAL VALLEY, 2015)*
In photographing California's Imperial Valley, NASA substituted some of the green shown in its true color photographs with a red hue. The two spheres above show differences between a naturalistic use of color and *false color imaging*. This technique was used to differentiate green organic matter, which reflects infrared light, from green inorganic matter, which does not. Since infrared light captured by cameras is invisible, it was shaded red to make the location of plant life visible.

FIG. 3 *NORMAL COLOR MAPPING (AS SHOWN IN THE PHOTOGRAPH OF A WHITE DOOR, 2017)*
In the photograph of a white door (Fig. 4), red, green, and blue lights were placed in a dark room to cast colored shadows and light. The two spheres above show differences between a naturalistic depiction of color and *normal color mapping*, the computer graphics mode of coding surface geometry with artificial colors.

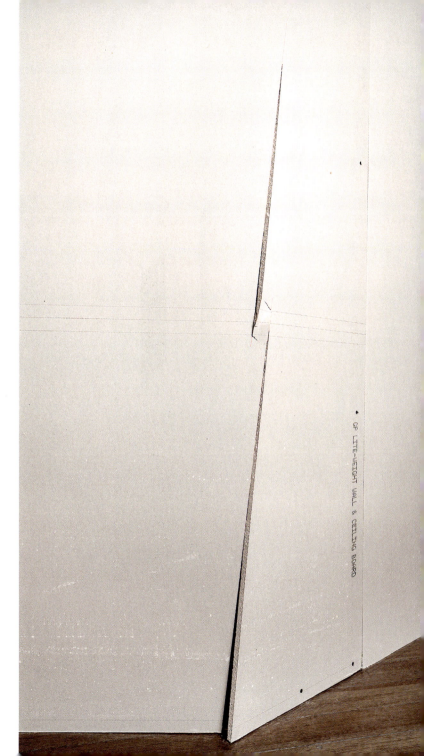

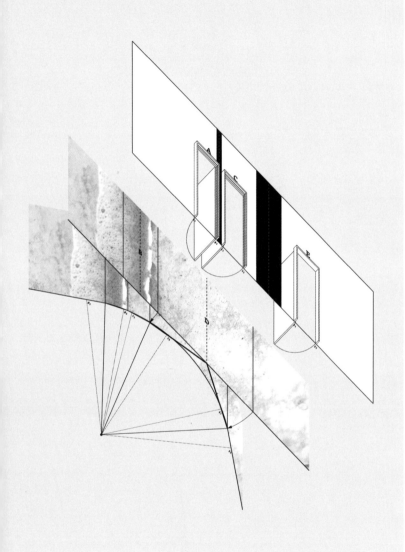

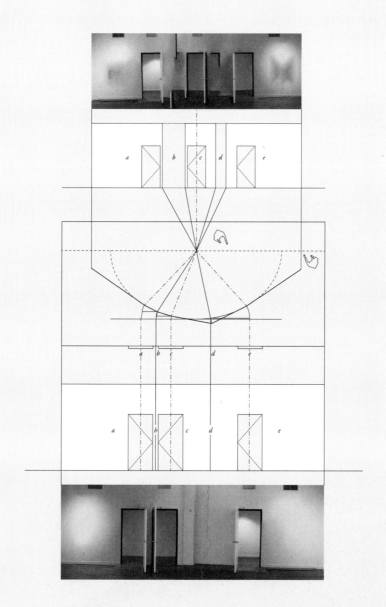

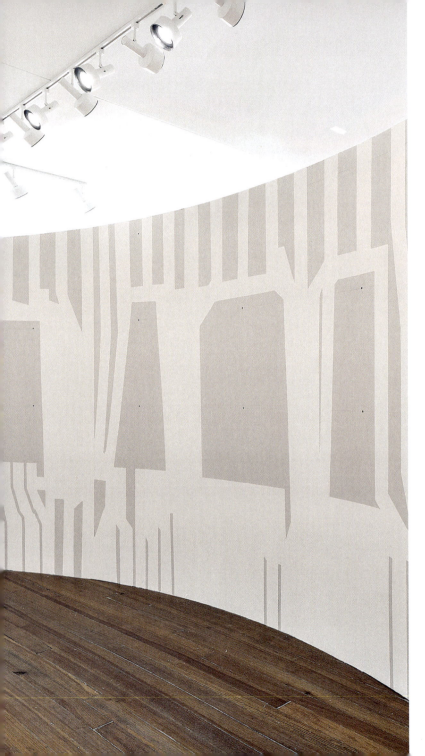

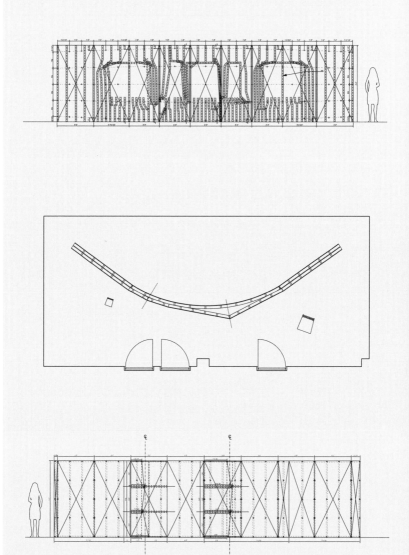

Noise

In the summer of 1982, the science fiction movie *Tron* was released two weeks before another cult classic, *Blade Runner*. The two films, produced by Disney and Warner Bros., respectively, combined an aesthetic of the future with an exaggeration of light. While *Blade Runner* experimented with the limits of traditional film techniques like matte painting and multiple-exposure superimposition, *Tron* played with illumination by incorporating computer-generated imagery (CGI). Disney hired the computer graphics company Mathematical Applications Group, Inc. to create many of the film's action shots, and on their graphics team was a research scientist named Ken Perlin, the inventor of the CGI industry standard for noise. Though noise had been a long-standing area of research in the sciences and military as an unwanted effect of recording, it was now being used to overcome the technical shortcomings of computer rendering. In CGI, noise creates the effect of randomness in a digital environment, whether in its surfaces, qualities of light, or the arrangement of objects and images.

 A fundamental deficiency of CGI in the 1980s was the unnatural representation of surfaces and light. Computer rendering had just been developed in the last decade by a group of engineers at the University of Utah, and the algorithms for surface shading and light calculation were still evolving. The smoothness associated with primitive computer rendering resulted from the mathematical idealization of surfaces in the digital environment. For example, light reflecting from a ball might appear as a perfect circle because virtual objects are simpler and faster to construct without the dips and cracks that make physical reflections irregular. In other words, things are easier to render without texture. Recognizing this, Perlin developed an algorithm that made surfaces more imperfect.

After working on the special effects software for *Tron*, Perlin continued developing tools for undoing the aesthetic qualities that hinder the realistic depiction of things. Observing that smooth surfaces and clean reflections looked fake, he applied noise algorithms to objects to make them bumpy and dirty. The filter also made transitions between rendered and filmed scenes less jarring since the texture it created could be mistaken for film grain. Four years later, with his knowledge in the entertainment industry, Perlin published his seminal paper on noise, "An Image Synthesizer."[27] Perlin noise, as it is now known, is a computer graphics filter that uses mathematically generated images, or procedural maps, to create surface texture. When overlaid onto cubes, planes, or other simple geometries, the maps simulate a visual complexity found in "clouds, fire, water, stars, marble, wood, rock, soap films and crystal."[28] The process differed fundamentally from previous noise techniques in that it presented a stochastic, or randomizing, function in three dimensions. Perlin called this effect "solid texture," and unlike the many computer graphics projects funded by the government, it was used for artistic effects at the outset.

Developing Perlin noise proved a complex problem because it had to achieve both a seamless appearance and endless variation. This was done by spreading pseudo-randomly-directed vectors across a grid, with each vector becoming the center of a gradient tile. Pseudo-random functions are efficient at simulating nature because they are deterministic—generating planned outcomes—yet indistinguishable from actual randomness. Each gradient tile is blended with other nearby tiles to make a continuous field, distorting simple objects according to their color values. With his gradient field, Perlin found a way to create

mathematically predictable textures that were just varied enough to evade human perception.[29]

While noise came to be valued in early computer graphics for its ability to make renderings more realistic, it continues to have a complicated status in other visual arts.[30] Attitudes toward noise depend on how the functions of the instrument and the image are understood in relation to one another. If the function of the instrument is to *record* the real world and that of the image, to open a window onto that world, then noise is undesirable. To put it differently, noise is perceived negatively when it results from an instrument's technical limitations and when the image is meant to be an objective representation. For example, cameras with small sensors produce terrible photos in dim light because noise obscures details. Deviations from true colors and shapes reveal the camera's inability to create an accurate reproduction. In short, noise is problematic when the instrument intervenes in a scene like a dirty window obscuring one's view.

Yet noise can have a positive effect when an instrument's function is to *fabricate* the real world and the image is intended to imitate another medium. In the twentieth century, CGI was prized for building total environments from blank screens, just as in the fifteenth century, linear perspective was marveled at for its ability to construct entire worlds on paper with a system of intersecting rays. With perspective, however, the totality of drawn projections did not account for the capriciousness of matter and light, so artists like Piranesi added hatching, a secondary and more interpretive method. His Roman temple etchings, for example, use dense parallel lines to cast the figures of marble columns into the afternoon sun. Though his shading techniques lie outside perspective's objective framework,

Piranesi's marks were not viewed as inaccurate or accidental. Instead, they followed the artistic technique of hatching and were judged by standards used for the medium of engraving. Such an interpretive method was desirable because it allowed drawing to surpass the aesthetic limits of objective representation.

Similarly, Perlin added noise filters to digital images to compensate for their lack of materiality. His rendering *Ocean Sunset*, for one, is an aerial view of waves with flecks of yellow on a gradient of burnt sienna, rust, and ochre. The rendering is too orange and high contrast to be an accurate reproduction of an ocean, but it is a convincing imitation of a good photograph of one. Around the time when the image was published in 1985, lens filtering and color enhancement were familiar enough film editing techniques that the rendering's deviations from true color could be interpreted as an intentional effect. More than any actual ocean, the false coloration of "Ocean Sunset" is reminiscent of the ocean depicted in the movie *Solaris* (1972), and its contrast values are comparable to the opening Indian Ocean scene of *Top Gun* (1986). Though it was technically possible to approximate the appearance of water more closely, Perlin's image copied film.

CGI's stylistic and textural imitation of other media enabled viewers to perceive noise as an artifact of production rather than reproduction. Noise was used quite literally to build up flat planes into raised surfaces—like the metamorphosis of the ocean into the earth's crust—with the same process that added grain to 2D pictures. New worlds emerged from layering maps onto existing conditions, not unlike using lens filters in film. For example, director Andrei Tarkovsky and cinematographer Vadim Yusov shot *Solaris* through an anamorphic lens, using its distortion to make the

space station seem otherworldly. Director Tony Scott and cinematographer Jeffrey Kimball recorded *Top Gun* through warm graduated filters to make San Diego look dramatic. Likewise, Perlin applied a noise filter to *Ocean Sunset* to such a noticeable degree that deviations from real-world references could be taken for artistic license. It was exactly this amplification of light and color in early CGI that took noise out of a scientific framework, allowing viewers to encounter noisy images aesthetically. It is as if one had to capture the world *through* noise to construct it anew.

In these contexts, noise is not perceived as information loss—as it would be in a bad low-light photograph—but as a surplus. Here, the dirty window gives digital images a materiality and ambiguity that overrides their tendency toward abstraction. Perlin likened his process of adding digital noise to images to using a paintbrush on a canvas, comparing pseudo-random functions to a brush's bristles. Each makes unpredictable marks, giving the artist a "controlled random process" to make pictures irregular enough to look interesting.[31]

⬢

What can we infer from the disparate responses to noise? Are they simply reflective of divergent values in the arts and sciences, or do these differences in attitude have broader implications?

To start, it is important to reflect on the cultural context in which Perlin noise was invented. Historians of science Lorraine Daston and Peter Galison describe the twentieth century as a period when objectivity came under scrutiny in the sciences amid an evolving sense that objective techniques couldn't fully capture natural phenomena. In their

book *Objectivity*, the authors describe how scientists' approaches to representation moved away from a commitment to self-denial and strict procedures toward an acceptance of the indispensability of judgment and interpretation. During this time, a cultural distrust of machinic reproduction also primed viewers to embrace images manipulated by experts. For example, in medicine, x-rays overlaid with doctors' drawings became a valued diagnostic approach because the markings skillfully distilled details into useful information. The maxim of objectivity— "let nature speak for itself"—was replaced by a sentiment that "the real emerged from the exercise of trained judgment."[32] This cultural backdrop favoring interference was perhaps, by extension, more receptive to the introduction of noise.

Perlin noise was an appealing technique for a twentieth-century audience because it recovered a framework for seeing the world that had long been unavailable.[33] On the surface, gradient tiles defied regularity, modulating the environment between clear/unclear, ordered/messy, and clean/dirty. On a deeper level, the gradients transformed the pictorial systems to which they were applied. In black areas, the existing system remained; in gray and white areas, it deformed. The rules governing image construction alternated between those of 2D/3D, screen/model, and electronically lit/daylit space. It was as if the vectors shaping each gradient were snags in the threads keeping perspective, and other totalizing systems, intact.

The algorithm recast space through an interpretive lens—a reproducible texture that encompassed falling leaves, ocean waves, and everything else deemed unpredictable. The filter marked the presence of an expert eye capable of converting data into effective images, like a radiologist's notations on a body scan. In this case, the

expert was Ken Perlin, and his mark was an algorithm encapsulating his idea that infusing difference into CGI was essential to conveying naturalistic objects, albeit in a simulated way.[34] In actuality, noise didn't exist independently from representation; it simply expressed an idea of how the real world works.

That noise is detached from any concrete references yet is widely used in mass media is significant. It suggests that it can operate symbolically. Perlin's procedural map uses mathematical functions to represent concepts about natural phenomena, and though it may have analogies in technologies of the past, the texture is unmistakably digital. The process requires calculating dot products from many vectors to establish gradient tiles, a tremendous undertaking for a person but an easy task for a computer. Considering that a ripple of water is the result of at least four vectors, one can imagine how many multiplications an ocean surface requires. These formulas visualize a style of randomness such that calm seas become choppy and straight hair turns wavy, but always in similar ways. With true randomness, forming consistent textures is impossible. Perlin's pseudo-random process is predictable, giving it a recognizable character, and yet its lack of referents makes the pattern abstract enough to signify many things. Rising in popularity amid a cultural shift away from objectivity, noise offered a suitable framework for expressing tendencies toward interference visually *and* symbolically.

In his 1927 book *Perspective as Symbolic Form*, art historian Erwin Panofsky argues that the invention of linear perspective arose from the beliefs and values of the Renaissance. For Panofsky, the drawing technique was an abstraction of *reality*—of one's "subjective optical impressions."[35] Constructing pictures with mathematical

relationships like parallelism and convergence, based on the assumption that space narrowed to a single viewpoint, reinforced notions of individualism; the idea that optical sensation operates as a planar slice through an immaterial pyramid supported rationalism.[36] Panofsky suggests that perspective was not a natural representation of the physical world but rather a convention of seeing that arose from its widespread use. Over time, floor tiles in Renaissance paintings were more readily seen as grids receding into space than trapezoidal figures on flat surfaces. The depiction of virtual space grew to eclipse material presence such that the perception of vaulted interiors overtook the existence of pigment on plaster walls, and ideal cities superseded tempera on wood. The technique's network of invisible lines captured a Renaissance ethos and conveyed these ideas through a pictorial structure laden with meaning—a symbolic form. Perspective converted "psychophysiological space into mathematical space," thus objectifying subjective sensibilities.[37]

Like perspective, noise represents the world in two dimensions and reflects deeper beliefs about how that environment is organized. With popular titles like *Tron*, viewers were immersed in its conceptual framework. If we were to consider noise as a symbolic form, its field of locally convergent vectors would signify multiple subjects (as opposed to the single spectatorship of perspective), its seamlessness would indicate a world composed of soft boundaries, its pseudo-random equations would express chance as pervasive but predetermined, and its black-and-white gradients would imply fluctuations between counterparts. As a symbolic form, the filter creates not only something we can see in the randomness an instrument constructs to copy the style and texture of other media

(fabricated noise). It has also become an entire way of seeing. Noise is an illusion of space—a representation of the idea that randomness inheres in the real.

By examining the wider implications of divergent attitudes toward noise, which can be seen in techniques like Perlin noise and low-light photography, we can reflect on our changed ways of seeing. Consider how Perlin's pseudo-random process allows an algorithm to be effective as a filter *and* a symbolic form. Procedural noise forms a continuous texture such that turbulence and wood grain can appear to be part of a surface, rather than sitting on top of it. This is unlike a doctor's drawing on an x-ray because the diagram that restructures sensed data is invisible. One can see how an algorithm changes an image, but the vectors at work are hidden. Algorithmic noise is not only endless but also seamless, unlike film grain that can concentrate in shadowy areas with increased exposure. The contour shaped by these grains reveals where a camera and film fail to reproduce reality, and in that sense, recorded noise can diagnose an instrument's defectiveness. Figuration renders error legible and dispels the coherence of the apparatus. Perlin noise is illegible due to its lack of edges and thus maintains a continuity necessary for it to function as a symbolic form.

Seemingly without error, fabricated noise embeds materiality into virtual space as dirt (small scale), waves (medium scale), and cities (large scale). In doing so, it also introduces ambiguity into how images are made. In *Blade Runner 2049* (2017), the visual effects company Framestore used procedural textures for dirt, sand, dust, and rust to create "as much randomness and varied breakup as possible."[38] Avoiding the appearance of tiled textures—a grid of seams—was imperative to immerse viewers in the dystopian atmosphere of a future Las Vegas. The movie's weathering

effects were inextricable from the city's composition because the procedural maps are boundless, like the environment itself. Did a CGI team assemble every object in *Blade Runner 2049*, or did they apply an algorithm? That we can now watch depictions of cities with hundreds of skyscrapers that may have been algorithmically generated *or* built slowly by hand affords a particular imagination of things appearing on-screen and perhaps also in the real world.

Today the presence of algorithmic noise allows audiences to see dirty and haphazardly arranged objects as the result of an ordered, rather than a disordered, process. Tolerance grows for compositions that fit under the style and texture of noise as the depiction of materials in movies and other popular media intertwines with digital space. The perception of aged floorboards oscillates with that of mathematical filters on planes. These concepts of form, composition, and process were not something that were always there, waiting to be discovered by technical innovation. More likely, algorithmic noise formulated vague sensibilities already underway. The technique showed how communicating and making things in alignment with these tendencies could be done and thus helped to bring the category of noisy environments into being.

●

Does recognizing noise as a symbolic form have any bearing on physical space? One could argue that the rise of noise as a symbolic form is a symptom of an aestheticization of difference. Society increasingly operates in the realm of symbols instead of materials, and aesthetic interference does not equate to social resistance. For example, filmmakers applying noise to an image of a city may signify a new kind of urban

space but in doing so can neither give rise to changes in property nor grant anyone new freedoms. Noise's grid of vectors operates only on the surface, such that its virtues are signaled but not enacted. But one could also see noise's continued presence since the 1980s as having concrete yet indirect influences on the world. For instance, urban designers applying noise to a map of a city (as in a zoning overlay) reconfigure urban space, which does give rise to changes in property.[39] In disciplines like urbanism, landscape architecture, and architecture, noise helps construct worlds, just as perspective has since the Renaissance.

The significance of noise today lies in its capacity to articulate contemporary ideas through techniques and to facilitate action that aligns with those concepts, which are sometimes too nebulous to define. Essentially, noise constructs a mode of seeing that can give form to otherwise ineffable states of being. Perlin's algorithm embodies an unknowability (as in the lighting in *Tron*) that produces an image of the future and a familiarity (as in the film grain in CGI) that delivers us to a material realm. It presents a way to understand space as something simultaneously extraordinary and ordinary, projective and grounded. By taking an adverse effect of signal transfer—its randomness—as a predictable and pervasive texture, noise represents a quality that pervades our environment yet evades our sensed experience. The ubiquity of noise indicates a break from earlier perspectives that saw the world as a clean slate, tabula rasa, or ground to be tended.[40] These earlier viewpoints regarded surface interference as deviations from an ideal. Yet to adopt noise as a way of seeing is to embrace unpredictability and irregularity as integral to the material world, one where pervasive difference is as open to intervention as the designed environments shown on-screen.

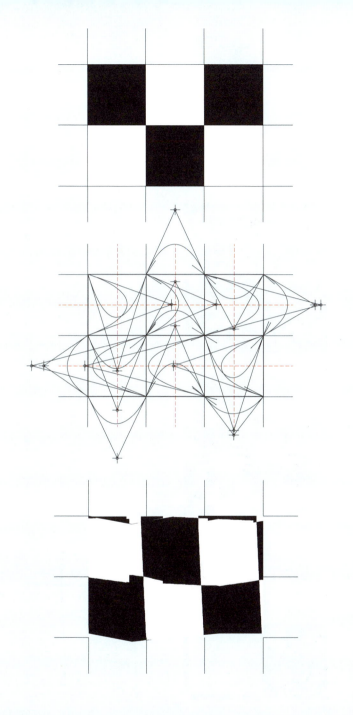

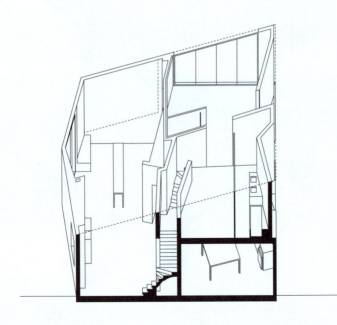

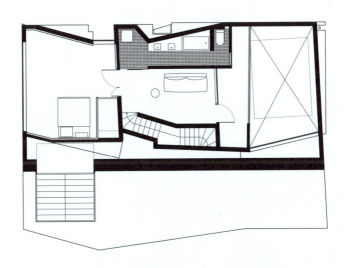

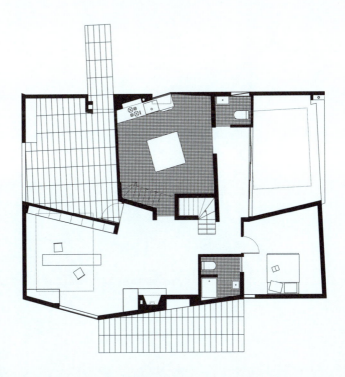

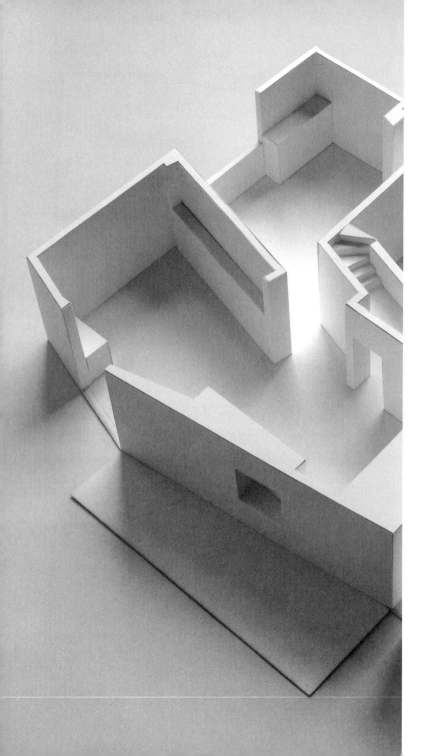

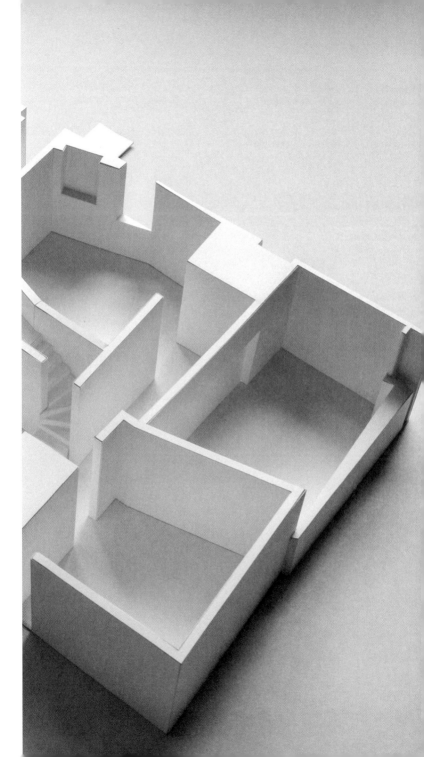

Shadows and Other Things

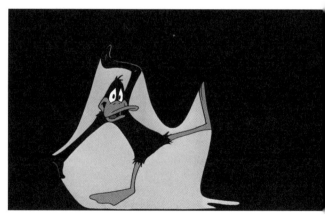

Fig. 5
Still from "Duck Amuck" episode,
Looney Tunes, by Charles Jones, 1953.

In the opening scene of the 1953 cartoon "Duck Amuck," Daffy jumps into the picture and, dressed as a musketeer, wields a sword at a nearby adversary. Or that is what we assume he is doing. He charges left, and the camera frame follows as if it were being pushed by the tip of Daffy's blade. The countryside that is the background loses color with every stroke of his sword until the duck is left in a white rectangle. He stops, takes a look around, and is bewildered by the void. It is at this point that Daffy addresses "whoever's in charge here" and a new scene is drawn in. An absurdist pattern repeats itself for the remaining six minutes: Daffy grows accustomed to his new conditions until suddenly a large pencil or brush changes them, rendering him out of place. We sense an invisible hand at work, but it is not until the end of the cartoon that the animator is revealed to be Daffy's longtime rival, Bugs Bunny. In the closing act, we see the rabbit drawing on a page, leaving us to wonder if the familiarity of the strokes of his pencil is only a coincidence or an intentional echo of Daffy's sword.

Daffy's torment is shown to be at the hand of Bugs, with one exception. Five minutes in, the duck is standing alone inside a teal rectangle when a black blob falls on his head. The blob droops down from the top of the screen as if it were a ceiling that took on too much water. Bugs momentarily sides with Daffy, painting in a pole for support. But the wood snaps. Suddenly, the mass expands from all sides in spite of Daffy's efforts to hold it up. The black frame that once gave structure to his environment grows into something that smothers the duck. The duck pushes back, thrashing wildly until he tears the blob to shreds. Is this the unseen opponent Daffy was looking for?

The style of midcentury *Looney Tunes* cartoons makes the presence of the frame all the more subject-like.

Animations of this era rarely contain shadows, as they adhere to a graphic approach. The black frame thus cannot be construed as an effect cast by an object out of sight. Rather, it is an apparent subject that is always present, if not always visible. It is not that Daffy and the black shape never occupy the same space but that the characters are asynchronous. If the animation were slowed to quarter speed, we would perceive the frame as a blurred line tracking across the screen. But it sits motionless in the background when viewed at the speed necessary to bring the protagonist to life. By the time Daffy takes notice of his technical supports, they have already fallen and hit him on the head.

 How easily the frame loses its consistency. In a viscous state, the frame no longer acts as a constant to the animation, and we have to draw from the cartoon's internal composition to find order. It is exposed as a fragile element in a larger representational framework. Antique perspective exhibited a similar weakness compared to the modern method, as it did not have the spatial unity that a central vanishing point afforded. Without a uniform method for depicting space, compositions appeared more disorganized and filled with objects that took on bodily forms. Relationships among elements were inconsistent and remained locally contingent.

 Where "Duck Amuck" is unlike antique perspective is in its presentation of the frame as a subject. For art historian Erwin Panofsky, art in antiquity was concerned with the real and thus only showed visible and tangible things. What do we get by expanding to the unseen?

 Twenty years after Warner Bros. Pictures released "Duck Amuck," Francis Bacon completed *Triptych, May–June 1973*. The painting was one in a series of three Black

Triptychs Bacon painted in the 1970s, after the death of his lover, George Dyer. Each of the three panels in *Triptych May–June 1973* measures six feet, six inches by four feet, ten inches; so large is the piece that it takes time to see it. Standing in front of the work involves observing it panel by panel—frame by frame—such that finding similarities among its repeated figures, doorframes, and colors might require moving one's head in a pattern that traces the bodies' disfigurements.

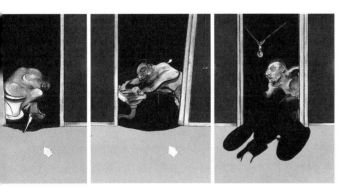

Fig. 6
Triptych May–June, 1973 (CR 73-03) by Francis Bacon. © The Estate of Francis Bacon. All rights reserved. DACS, London/ARS, NY, 2023.

From what we know of Bacon, the artist was uninterested in representation and narrative, so much so, in fact, that he sought to eliminate the spectator from his work. He substitutes the viewer with what Gilles Deleuze calls a "witness," one who "is integral to the Figure and has nothing to do with a spectator" and serves as a "reference object or a constant to that which deems itself a variation."[41] In other words, the witness is someone (or something) that is

necessary to the body, always there. Presence, rather than sight, characterizes the witness. Its character lies within the rhythm it establishes to keep the eye moving across the work.

With the many repeated elements in *Triptych May–June 1973*, any number of things could stand witness to the scene. A figure, a doorframe, a wall, a shadow. Unlike in his other Black Triptychs, here Bacon places the human figure behind the plane of the wall. Filling the doorframe, black is at once an umbral background that gives definition to the body and a penumbra that softens the mass. In the central panel, however, the black does not completely follow the rules of shadow casting—it is so geometrically foreign to the body that a mimetic relationship does not hold. Like the paintings' architectural elements, blackness is a constant among the panels. But unlike the door and wall, black is continuous with the changing body, allowing our eyes to track its differences. In *Triptych May–June 1973*, the witness is a black mass convoluted with the body.

To elevate the witness and diminish spectatorship, Bacon portrays material objects as forces to contort bodies. For Deleuze, "the material structure wraps around the outline to imprison the Figure that accompanies the movement with all its might."[42] Flat material objects such as walls, floors, and shadows act on the apparent subject like Daffy's antagonist. Their contortions present material and subject as inextricable from one another. The body tries to tear away from the shadow, the shadow tries to tear away from the body, but both are unsuccessful and so remain mutually contingent. Bacon's disposition toward blackness is nonbinary insofar as tangencies to bodies are not just territorial but also involutional. The eye's circulation around the triptych panels and depicted objects invokes a kind of

tackiness that fixes attention to the material plane. Unlike perspective, which includes the viewer inside the space of the picture, the impenetrable plane of Bacon's triptych holds our attention through an internal dynamism, much like animation.

What is gained by treating the unseen as a subject? For one, the witness presents a different kind of viewership. Perspective, which encompasses its audience in a visual pyramid, places the physical spectator somewhere anterior to pictorial space and posterior to an imagined realm. The totality of perspectival projection's mathematical idealization is indispensable to this effect of three-dimensional space, such that any askew line might disconnect the represented from the material.[43] Linear perspective sets up a system that suggests the entire world could be known, if only we could turn around to see it. Understanding the representational framework of our environment—the unseen—as a witness means presenting it as a material subject. Daffy's frame and Bacon's black figure are not merely preconditions for depicting objects and space; they are autonomous and equal to other subjects.

The frame is a diagram of that which is always there but perpetually displaced by its otherness. "Duck Amuck" and *Triptych May–June 1973* both subvert the frame's traditional role. For Bacon, a shadow is de-othered by its relation to the body (involuted and inseparable) and continuous presence (witness); for Daffy, a frame is de-othered through its movement (synchronous and perceptible) and narrative agency (antagonist). The frame that was once "nowhere" is placed in the scene. According to Darell Fields, prevailing thought stemming from the Enlightenment "wants us to believe historical errors are corrected by subjecting them to negation (i.e., thesis, antithesis, and synthesis).

It suggests that the material natures of the errors, beings or objects, are dissipated in the process."[44] Frames and shadows in the animation and painting are exaggerated and thus removed from their conventional roles to such a great degree that these exaggerations cannot be considered an error. They are neither lacunae nor caesurae nor holes to be filled. Instead, the black forms are constitutive elements that act on, organize, and set forth the whole. Within these works is a proposition to make the unknown visible, not by bringing it to light, but by giving it presence as an inscrutable subject on equal footing with the subjects we know.

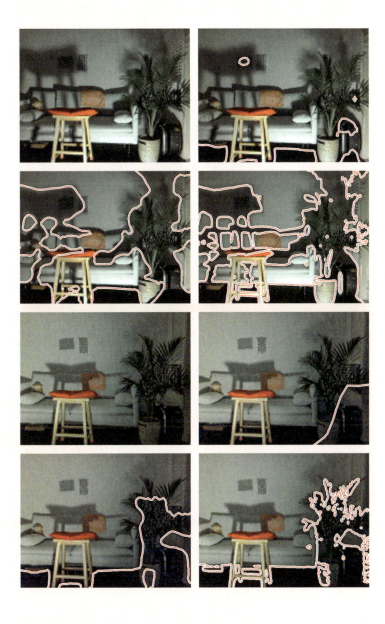

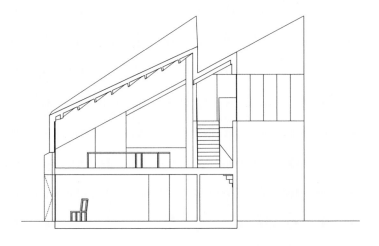

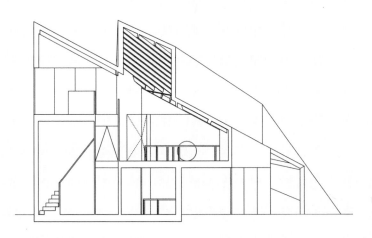

Down the Loss Landscape

Under an atmospheric veil, one tower of the Golden Gate Bridge is hidden from its counterpart. The veil has two states, depending on when the missing object begins to surface. If the tower appears before the midpoint of the deck, it is labeled as mist; any later, it becomes fog. Were the veil to hover above the bridge, it would be called a cloud.

The classification of weather events isn't merely a conceptual exercise; it carries practical implications for safe travel. Institutions like the National Weather Service and the World Meteorological Organization sort obscuring phenomena by how far one can see through them, providing general guidance for navigation through air and across land. One kilometer of visibility—half the length between the towers of the Golden Gate Bridge—is the typical boundary separating mist and fog, when drivers are cautioned to slow down and turn on their lights. When weather conditions reduce sight to a third of that distance (around 1,100 feet), the Federal Aviation Administration enforces Low Visibility Operations, mandating changes in flight routes, marking, signage, lighting, and detection techniques to guide planes to the ground.[45] Visual references are deemed unreliable—horizons are fuzzy, distance is distorted—so government agencies require pilots to rely on rules and instruments.[46] Walking in these conditions carries similar risks, though on a smaller scale.

Fifteen miles north of the Golden Gate Bridge is a full-day hike to summit and descend Mount Tamalpais. When skies are clear, the 786-meter peak is visible from as far as the eastern shore of the San Francisco Bay and up close from Fire Lookout and Inspiration Point, among other vistas. Yet beneath the fog, the mountain's form wavers, prospects shrink, and the trek stretches on indefinitely. Cracking twigs, whispering leaves, and fleeting scents might further

confuse depth perception. Trail markings can blur beyond recognition, making it important to check other wayfinding devices often, but not so much that it slows you down. In this limited view, measuring the terrain at a steady pace ensures the accuracy of its description and a hiker's safe arrival to familiar ground.

A hiker navigating through the fog is one of the analogies commonly used to describe an optimization algorithm in machine learning called "gradient descent." Machine learning is a branch of artificial intelligence that loosely mimics human learning with models and algorithms that gradually improve over time. An algorithm is a series of encoded actions run on data to distill information, and a model is a representation (often a program) of the rules and structures organizing that information. Algorithms shape models, tweaking parts iteratively until the model can accurately reflect the patterns found in existing data to predict new data.

Consider the task of training a model to distinguish pictures of bridges from pictures of mountains. This undertaking requires feeding thousands, sometimes millions of photographs into an algorithm and adjusting its parameters until the model can predict which images belong to each category. The model might start by conflating the cusp of a suspension bridge cable with a mountain's elevation before learning that bridges follow ideal geometries and mountains are absent of them. This iterative process places the model in a constant state of formation, evolving with each pass of the algorithm, continually building new representations to find order in what it "observes." What guides this process of self-correction is most often gradient descent.

Whether a hiker in fog, a blindfolded man, or a blind person, the protagonist used to personify this complex

process remains short-sighted, signifying their liability to stray off course. On the trail, the hiker, with their wayfinding device, represents the optimization algorithm, and the mountain represents the error from all possible functions. Like the hiker who descends the mountain, the algorithm searches for avenues to reduce errors. Checking the wayfinding device is equivalent to the algorithm computing the gradient—a vector pointing at the steepest increase in error. The hiker who takes the fastest way down the mountain moves in the opposite direction of the gradient, toward the steepest decrease. How far they walk before checking their instrument is called the "step size," and any changes in direction correspond to updates in the algorithm's parameters. Ideally, the path doesn't meander but is direct, or optimized.

The mountain is also known as the "loss landscape." Its peaks represent parameters creating the worst predictions, yielding the greatest difference between what the model generates and an accurate depiction. There is no loss when a model's inputs and outputs match, so in a sense, loss is a measure of how much error the model introduces into the data it receives. This landscape comprises a field of vectors whose arrows point toward increasing error—or, in keeping with the analogy, deeper into the fog.[47] The steeper the slope of any vector, the faster the machine learns and the faster the hiker absorbs readings from their instrument (also not unlike a pilot expertly flying under Low Visibility Operations). Slopes at any point in the landscape are found by taking mathematical derivatives, which we can imagine as a measurement system the hiker fashions by laying down planks of wood in the direction they want to take. This technique reduces a highly specific terrain to a series of simple lines. Ultimately, the steepest route for the hiker is

the best model. But using long planks (large step sizes) runs the risk of moving them suddenly into a peak, while relying on short planks (small step sizes) slows down progress. Building this new ground of the loss landscape is an important abstraction that is used to propel new outputs with observable differences.

Fig. 7
Joseph-Benoit Suvée, *Invention of the Art of Drawing*, 1791.

 Essentially, the hiker who makes their way down the mountain does so by slowly drawing it. They trace the ground's contours, approximating the landscape to a level of detail corresponding to the rhythm of their measurements. Drawing helps the hiker commit an object to memory, like Kora of Sicyon tracing her lover's profile before he left Corinth. As depicted in Joseph-Benoit Suvée's *Invention of the Art of Drawing* and described in Pliny the Elder's *Natural History*, Kora uses a charcoal stick to outline the shadow cast by candlelight onto a young man's face. She fixes her

attention on the silhouette while her subject embraces and gazes up at her. Upon seeing the finished drawing, Kora's father, a potter, fills the contour with clay, fires it, and furnishes a model of the lover in absentia. He makes a relief in the man's likeness, a kind of mask, but his contact with the subject is only indirect.[48] Kora's drawing is a template for the potter's construction, so his work is untouched by the original. We could say that his is a process of *projection*—of bringing a new object into being—while Kora's is one of *representation*—of transferring an original subject to an image.

Like Kora, the hiker is drawing but does not exactly represent their subject or project a new one. Whereas Kora and her father can see the lover's whole face (in person or mediated through drawing), trace it (with charcoal or clay), and visually compare his head to their work (physically or graphically), the hiker benefits from no such feedback loop. The hiker cannot look back and must always press forward in their drawing, meaning that—and this is crucial for machine learning—the figure they draw adjusts to what they learn about the object along the way. The hiker cannot render a mountain completely because the veil of fog blots out the drawing as it is constructed, slowly undoing what memories may have been preserved in the process.

What does this kind of drawing do, if not represent or project the mountain's form?

●

The legend of Kora has endured since Pliny's time because it allows us to reflect on themes of representation, imitation, memory, and loss.[49] Over the past four decades, architectural theorists have repeatedly turned to it to highlight differences between artistic and architectural drawing. In his 1986 essay

"Translations from Drawing to Building," Robin Evans contrasted painted renditions of the scene by the architect Karl Friedrich Schinkel and the artist David Allan to show how architectural drawing is distinct from drawing in the imitative arts. Whereas in Allan's painting the couple, lit by lamplight, are alone indoors, in Schinkel's interpretation, shadows are cast by sunlight and the couple is outside, surrounded by shepherds. Evans reads these differences to suggest that drawing had to precede architecture to be built and that practice was always collective rather than individual. Thirteen years later, Stan Allen expanded Evans's argument, comparing Schinkel's painting to Suvée's version, highlighting breaks between mimetic representations in Western art and the formal distortions in architectural drawing. Both arguments for architectural drawing as a projective enterprise hinge on a distinction between representation and projection. For Evans and Allen, then, the status of drawing as the work of the architect is not in question so much as the potential that lies in the technique of projection as a conceptual framework for design.

The space of projection, a gap opened between object and shadow, is an imaginative realm, and the act of projection—of inscribing rays of light—is the technique that gives definition to imagination. The separation between counterparts is productive for design because projection's transformative force requires a distance between opposites: 2D/3D, virtual/physical, visual/material, linework/earthwork, and architect/builder. As this distance widens, representation shifts away from reproduction and toward invention.[50] For Evans, the function of projection as an architectural concept is evident in buildings. In the Royal Chapel at Anet, the architect Philibert de l'Orme designed a complex "projection" between the tracery on an interior

dome and the floor paving directly below. Though claiming to have simply projected parallel lines that transpose a graphic from one surface to the other, the architect deftly applied projective geometry to transform the patterns for better spatial effect. The ceiling and ground exhibit visual traces of ideas advancing across space. For Allen, conventions of projection like anamorphosis and axonometry reveal that architectural drawing has long relied on nonmimetic operations. The perceptual distortions mobilized by these projections take drawings out of a natural way of seeing and thus render their ideas of construction visible.[51]

This view follows Kora's father's way of making form. Like Kora, the architect never touches the object, working only indirectly through drawing. It is only when an artisan transposes the drawing into materials that a building is realized. If we look at architectural practice today, however, the conceptual clarity of projection can no longer encapsulate the myriad representations involved in the creative process.[52] Projective techniques, like orthographic drawing, that once forged direct lines from drawing to building now make stops for imaging, digital modeling, scripting, and data processing. Administrative documents like schedules, timelines, cost lines, change orders, and bids now influence a building's qualities and form as much as pictorial representations. This proliferation of techniques brings about an evolution of ideas through a kind of translation that, if understood through the framework of projection, would be messy and complicated.

To better understand the transformations present in contemporary practice, one could think of the hiker's way of making form. By reframing their process as an architectural one, we can understand the loss landscape as an interplay between representation and projection. In the realm

of machine learning, when loss is low, the model generates a faithful reproduction of the data it receives. We can call this *representation* because the original is preserved in translation to a high degree. The model becomes a conduit for preservation such that the mountain appears as the same mountain. When loss is high, the model creates a poor copy of the data. We can call this *projection* because the original undergoes a metamorphosis, giving rise to a new object. The mountain is distorted into a new mountain or even a bridge.

Fig. 8
Diagram of the loss landscape showing representation and projection as a function of loss and the number of changes in an algorithm's parameters. Background image by Alexander Cozens, *Mountain Tops (A Mountain Study)*, ca. 1780.

The hiker makes an abstract form by drawing a graph of loss. The graph plots variables along a continuum from representation (low loss) to projection (high loss) across time (figure 8). At any point in this vast field is an algorithm written with a set of rules and structures to repeat a certain degree of change. In other words, the graph delineates a

map of many representational frameworks, each capable of transforming subjects to varying levels. Valleys appear in moments that are more representational than neighboring steps, and peaks arise when projection is higher. As a result, the mountain manifests as a collection of valleys and peaks, etched over time.

The literal form that the drawing references is a distant one. It is a pliable body that changes every time the algorithm restructures the model. The hiker's drawing depicts the extent to which the visible form adheres to its predecessors. Compare this to the process of designing a building, where there is no essential form approximated throughout a project's design stages.[53] Rather, each representation is a fragment responding to new information from a client, builder, budget, program, site, or material. Each part transforms the entire building through a dynamic process of correlating design documents. This fragmentation allows for quick, pragmatic responses aimed at preserving the project's viability. In this landscape, techniques for reproduction and invention occupy the same field, connected by leaps and detours, and the path one takes alters tendencies toward evolving ideas of how to approach design. For example, jumping off a cliff would result in an abrupt shift toward representation with no change in rules, as when one draws a plan that suddenly looks like a precedent. Walking on a high plateau would sustain constant structural change and projection, like drawing, then modeling, and then charting an installation.

The environment inhabited by the hiker is a space without projection. In the absence of distant views, markings are short and progress is slow. Fragmentation is the conceptual framework and transformative force for restructuring unknown subjects into workable parts: short path/

large mountain, long path/tiny mountain, and wrong path/ bridge. Here, architectural form emerges from a gradual process of finding derivatives to the rules and structures that define it. One could say that this kind of drawing reflects the mode of one's practice rather than an object. As such, the primary drawing for this way of thinking isn't the plan or the elevation; it's the schedule.

Machine learning gives us a conceptual framework previously unavailable—a contemporary diagram of an architect's relationship to representation. Popular algorithms like gradient descent are interesting because their approach to representation fundamentally differs from classical techniques like projection. Because ordering systems in machine learning are dynamic, the objects they define are only fleetingly represented under one framework before another is built.

The process of fragmentation in machine learning privileges structural transformation, whereas projection in drawing privileges visual transformation.[54] These two frameworks are mutually productive. On the one hand, fragmentation redefines the binary between representation and projection as two extremes on a spectrum of loss. On the other hand, projection reframes error as invention. Misalignments between inputs and outputs have been generative in architecture, and they can be used to challenge the idea in machine learning that progress is a move toward better imitation.

●

Curiously, the fog is not assigned a character in the machine-learning metaphor. What creates short-sightedness is left undefined, perhaps to avoid metaphysical questions of

what (or who) has created so much uncertainty. The straightforward answer is that fog is data. The optimization algorithm cannot calculate beyond a step, just as the hiker cannot see beyond the single plank, because there is too much data to consider before advancing. Meteorologically speaking, fog is an accumulation of microscopic droplets of water, each blanketing a particle of dust. It is air that was once in a clear gaseous state but has been condensed into billions of spherical lenses reflecting and refracting the untransformed space around them. Like the fog in machine learning, it is too full of details to see through.

But the fog can also be read as a cognitive limit. Without it, the entire loss landscape could be instantly seen and known, and there would be no need for learning. With it, an algorithm must write and rewrite itself, like representation must be used to trace, retrace, draw, and withdraw to commit form to memory. Fog marks the collection of inputs bound by representation and projection, memory and construction. Its impenetrability covers all directions, so taking a step back does not guarantee that one can return to a previous position. In effect, fog shrinks an environment whose totality is too immense to be grasped, whether it be as abstract as a pixel field or as real as Mount Tamalpais.

In its obscurity, fog preserves one's intimate contact with a subject by preventing its total replication (representation) while also calling a multitude of things into being (projection). In Pliny's story, Kora has already looked away from her lover when she starts drawing. Her subject is abandoned, though still present. Had the shadow been blurred, she might have studied nuances in the continuous figures shaping nose and mouth, cupid's bow and lip, or tongue and palate, depending on the strength of the smoke, tears, or other interferences to the figure.[55] The representation could

have developed these curiosities under multiple frameworks to amass diverse and subtle interpretations of her subject. Similarly, fog can shrink the deep horizons of one's practice to ambient conditions, making space small enough to appreciate the complexities within various approaches to design. Through this veil, one can describe a mountain and, perhaps, build a practice. The density of this environment—be it mist, a cloud, or true fog—simultaneously brackets how far we can project into the future and grants us the freedom from knowing whether we're on the right track.

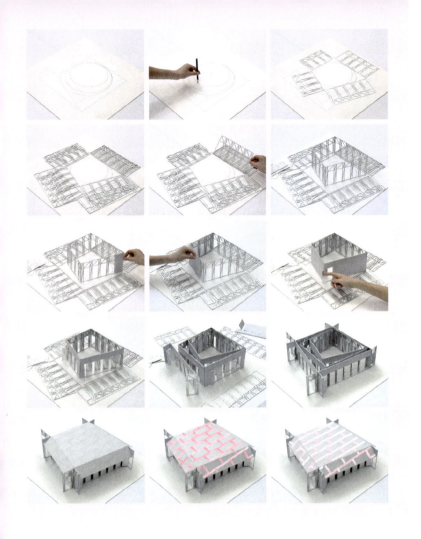

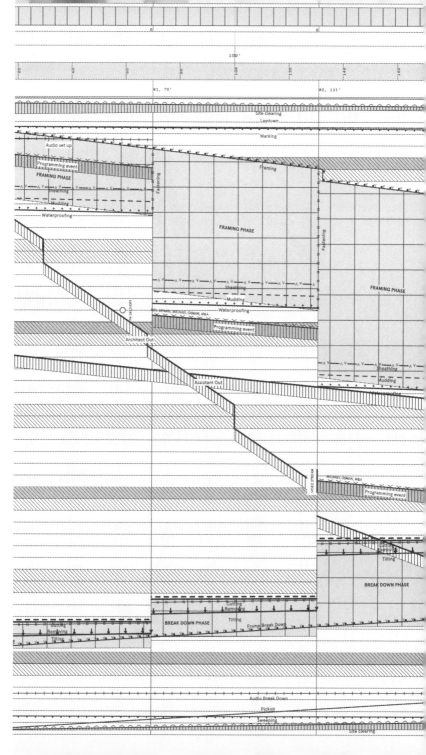

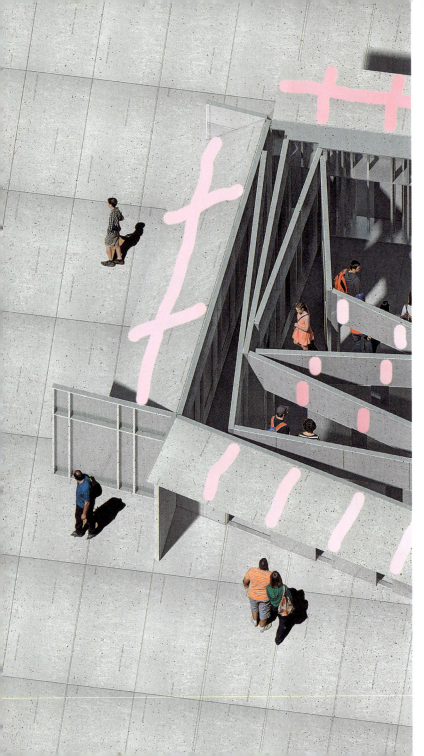

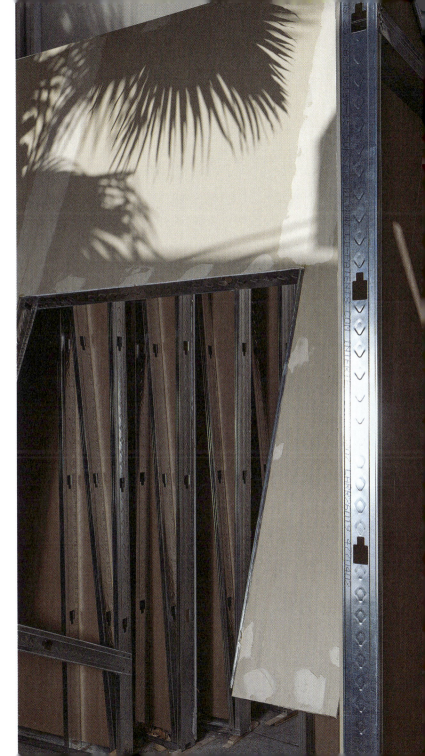

Notes

Earlier versions of "Something Vague" and "Noise" were first published in *Log*, no. 44 (2018): 103–113, and *PLAT 6.0 Absence* (2017): 152–157.

1 See K. Michael Hays, "Diagrams," March 24, 2020, *In Studio*, GSD Radio, 48:00, https://mixlr.com/gsd-radio/showreel/in-studio-diagrams.
2 Alain Robbe-Grillet, *Two Novels: Jealousy and In the Labyrinth*, trans. Richard Howard (New York: Grove, 1965), 60.
3 In the 1960s, the architect Robert Venturi referred to the phenomenon whereby multiple meanings arise from a "diversity of elements in relationships that are inconsistent or among the weaker kinds perceptually" as the "difficult whole."
4 Alfred Gell, *Art and Agency: An Anthropological Theory* (Oxford: Clarendon, 1998), 80.
5 Alfred Gell, "The Technology of Enchantment and the Enchantment of Technology," in *Anthropology, Art, and Aesthetics*, ed. Jeremy Coote and Anthony Shelton (Oxford: Clarendon, 1992), 40–63.
6 "The TARS have been located to overlap slightly from one area of coverage to another, like merging circles on a Venn diagram, to ensure unbroken coverage on the southern border." Dave Long, "CBP's Eyes in the Sky," *Frontline Magazine* 7, no. 2 (December 2015): 9.
7 "What here gives itself off as the minute and local is in reality the strategic new value of the fragment and the nontotalizable, the ephemeral constellation, the fuzzy set, the disposable, provisional, and fictive scale model. I think it is important to fight this particular battle out (a battle based, in my opinion, on a misunderstanding of what the concept of totality and the act of totalization really are." Frederic Jameson, *The Seeds of Time* (New York: Columbia University Press, 1994), 149.
8 Jameson, *The Seeds of Time*, 159.
9 Writing a recommendation into law can be quicker than building it. In fact, writing and publishing a book about buildings can be quicker than building them.
10 U.S. Customs and Border Protection, "Low-Flying Aircraft Detection Along the Northern Border," Fiscal Year 2018 Report to Congress, August 9, 2019, 2, https://www.dhs.gov/sites/default/files/publications/cbp_low-flying_aircraft_detection_along_the_northern_border.pdf.
11 Peter Sloterdijk, *Terror from the Air* (Los Angeles: Semiotext(e), 2009), 9–46.
12 United States Air Force, "Aircraft Accident Investigation Board Report," Executive Summary, Aircraft Accident Investigation, TARS, T/N 4220, Marfa, Texas, February 14, 2012.
13 Denise Scott Brown and Robert Venturi, "My Choice of Colour for the Vanna Venturi House," interview by Thomas Hughes, *Web of Stories*, September 22–23, 2006, video, 2:14, https://www.webofstories.com/play/robert.venturi.and.denise.scott.brown/11.
14 Nelson Goodman, *The Structure of Appearance* (Indianapolis: Bobbs-Merrill Co, 1966), 147.
15 See Rosanna Keefe, *Theories of Vagueness* (Cambridge: Cambridge University Press, 2000), 1–36.
16 Fire Service Act, Act No. 186, passed July 24, 1948. Unofficial translation available from the Japanese Law Translation Database System, https://www.japaneselawtranslation.go.jp/en/laws/view/3772/en. 2015 International Building Code, chap. 2, § 202.
17 Lotfi A. Zadeh, "Making Computers Think Like People," *IEEE Spectrum* 21 (August 1984): 26.
18 See John May, "Everything Is Already an Image," *Log* 40 (Spring/Summer 2017): 9–26.
19 Robin Evans, "Translations from Drawing to Buildings," *AA Files* 12 (1986): 5.
20 If Russell's description of vagueness sounds similar to Venturi's both/and phenomenon, this is no accident. Ambiguity is a close cousin of vagueness because it reveals the uncertainty in certain linguistic and logical structures. But in linguistic definitions, ambiguity is binary uncertainty, whereas vagueness is uncertainty involving unresolved or undistinguished entities. Bertrand Russell, "Vagueness," *The Australasian Journal of Psychology and Philosophy* 1, no. 2 (1923): 89.
21 For more examples, see Martin Jay, "Introduction: Genres of Blur," *Common Knowledge* 18 (January 2012): 220–228.
22 See, for example, Hernán Díaz Alonso's winning entry for the 2005 MoMA PS1 Young Architects Program and Reiser + Umemoto's West Side Convergence for the 1999 IFCCA Competition for Manhattan.
23 Greg Lynn, "Intricacy," in *Intricacy* (Philadelphia: University of Pennsylvania, 2003), 2–4.
24 In *Perspective as Symbolic Form*, Erwin Panofsky notes that in antique theories of space "the totality of the world always remained something radically discontinuous." Antique perspective depicted space using localized distortions, lacking the totalizing unity found in Renaissance perspective and subsequent ideas of space. Raster imagery returns to a pre-Renaissance notion of space because the pixelization of images renders it discontinuous. Erwin Panofsky, *Perspective as Symbolic Form*, trans. Christopher Wood (New York: Zone Books, 1991), 44.
25 Roy Sorensen, *Vagueness and Contradiction* (New York: Oxford University Press, 2008), 28.
26 William James, *The Principles of Psychology* (Cambridge, MA: Harvard University Press, 1981), 695.
27 Ken Perlin, "An Image Synthesizer," *Computer Graphics* 19, no. 3 (July 1985): 287–296. In the paper, Perlin uses the terms "naturalistic" and "realistic" interchangeably.

28 Perlin's noise algorithm also simulates natural processes like "falling leaves, swaying trees, flocks of birds, and muscular rippling." Unlike traditional texture mapping, which starts with images, noise constructs materials solely from mathematical equations.
29 This basic logic is similar to tile-based texture mapping, where "readymade" images are cropped to the minimum size that allows maximum variability. Finding suitable source objects, like a photo without parallax, is imperative to this approach. Texture tiles are rotated, mirrored, and repeated nonperiodically to replicate more extensive materials. Whereas texture mapping need only match figures along the repeated tile's edges, Perlin's gradient mapping takes on an image in its entirety.
30 The realism Perlin noise introduced into computer modeling was so valuable to the film industry that Perlin won an Academy Award for the algorithm.
31 Ken Perlin, "In the Beginning: The Pixel Stream Editor," Real-Time Shading Languages, SIGGRAPH Course 36 Notes (2002), chap. 4, https://redirect.cs.umbc.edu/~olano/s2002c36/ch04.pdf.
32 Lorraine Daston and Peter Galison, *Objectivity* (New York: Zone Books, 2007), 120, 355.
33 In *Perspective as Symbolic Form*, Erwin Panofsky describes the objects in antique art held together by an informal logic as "plastic clusters." With the invention of linear perspective, objects became regulated by a homogeneous mathematical space. Panofsky, *Perspective as Symbolic Form*, 41.
34 This attitude is similar to those found in indeterminate music. For example, John Cage used the I Ching method of coin flipping to compose his 1951 piece *Music of Changes*. Though the song sounds random and was written using chance, the score is fixed. The performance is prescribed yet imperceptibly so.
35 Panofsky, *Perspective as Symbolic Form*, 35.
36 In *Oblique Drawing*, Massimo Scolari notes that linear perspective captured and implemented the values of Western culture. It was thus rejected as a way of seeing by the seventeenth-century Chinese court because the implication of ocularcentrism in a single vanishing point was at odds with their philosophical ideals. Massimo Scolari, *Oblique Drawing: A History of Anti-Perspective* (Cambridge, MA: MIT Press, 2015), chap. 10.
37 Panofsky, *Perspective as Symbolic Form*, 31.
38 "*Blade Runner 2049* | VFX Breakdown | Framestore," video, 10:04, https://youtu.be/gQ8noORAJuc.
39 This process would create urban conditions in the lineage of "local variations" in open fields, as architect/theorist Stan Allen described in 1985, and "regular/irregular" relationships between cities and megastructures, as urbanist Colin Rowe and architect Fred Koetter explored in 1978.
40 *Rasa* means to scrape or shave, as with a *rastrum*, or rake.
41 "Bacon a besoin, dans ses tableaux et surtout dans les triptyques, d'une fonction de *témoin*, qui fait partie de la Figure et n'a rien à voir avec un spectateur.... Ce sont des témoins, non pas au sens de spectateurs, mais d'élément-repère ou de constante par rapport à quoi s'estime une variation." Gilles Deleuze, *Logique de la sensation* (Paris: Éditions du Seuil, 2002), 22. All translations are by JaJa Co.
42 "La structure matérielle s'enroule autour du contour pour emprisonner la Figure qui accompagne le mouvement de toutes ses forces." Deleuze, *Logique de la sensation*, 22.
43 There is an illusory totality to objective forms of representation, one that receives all light and encompasses all things. Every representational framework is in fact penumbral, as both total darkness and total light would give rise to blindness. Every representation is an election of parts necessary to complete a composition. In perspective, a lack of a unifying frame gives rise to a cacophony of multiplicities.
44 Darell Fields, *Architecture in Black: Theory, Space and Appearance*, 2nd ed. (New York: Bloomsbury, 2015), 113.
45 U.S. Department of Transportation Federal Aviation Administration, "Procedures for Establishing Airport Low Visibility Operations and Approval of Low-Visibility Operations/Surface Movement Guidance and Control System Operations, Rick Domingo," 8000.94A, Washington, DC, 2012, https://www.faa.gov/documentLibrary/media/Order/Order_800094A.pdf.
46 In aviation terms, fog is a weather category known as an instrument meteorological condition.
47 The algorithm is designed to compute the gradient only at each step. In the metaphor, then, the hiker probes only their immediate surroundings, as their vision remains obscured by fog throughout their hike.
48 We might also consider Bernard Picart's etching *Discovery of Sculpture* (1727), in which smoke rises from a pile of fired clay in the corner of the room. If Kora is the architect, her father, Butades, is the builder who shapes earthwork from flat lines.
49 For more examples, see Robert Rosenblum, "The Origin of Painting: A Problem in the Iconography of Romantic Classicism," *Art Bulletin* 39, no. 4 (December 1957): 279–290.
50 In "Translations from Drawing to Building," Robin Evans connects projection to loss: "What comes out is not always the same as what goes in. Architecture has nevertheless been thought of as an attempt at maximum preservation in which both meaning and likeness are transported from idea through

drawing to building with minimum loss. This is the doctrine of essentialism. Such essentialism was held to be paradigmatic throughout the classical period. It was held to in architectural texts, but not always in architecture. The notable thing about the working technique used by de l'Orme, which could only be written about from within the limits of architectural theory as a way of moving truth from here to there, was in the enchanting transfigurations it performed. Curiously, the pliability of forms was made possible by a homogenization of space."

51 Stan Allen, "Constructing with Lines: On Projection," in *Points and Lines: Diagrams and Projects for the City* (Princeton: Princeton Architectural Press, 1999).

52 This applies to contexts where legal codes place stringent managerial constraints on the building process.

53 Architectural services comprise schematic design, design development, construction documents, bidding, and construction administration.

54 In the medieval period, the plan was the sole representation from which a building was formed. Like the potter, masons constructed buildings entirely from drawings marked on the ground, making something that conformed to the plan but was still altogether unpredictable in form. Architecture's obsession with drawing as mimetic (and nonmimetic) of a finished building form did not arise until the Renaissance, with the tradition of correlating orthographic and perspective drawings like plans, elevations, sections, and renderings. See Scott Cohen, "Misrepresenting the Plan," lecture, Princeton School of Architecture, February 16, 2017, online video, 1:34:49, https://vimeo.com/204890825.

55 In his 1749 essay *Letter on the Blind for the Use of Those Who Can See*, Denis Diderot describes the influence of vision, or lack thereof, on one's understanding of the environment. The blind man, he writes, "has a surprising memory for sounds, and can distinguish as many differences in voices as we can in faces. He finds in these an infinite number of delicate gradations which escape us because we have not the same interest in observing them." Small folds in the mouth and adjacent passages affect vocal resonance and timbre in the way that thread patterns can make sheets soft or rough to the touch. Subtle anatomical variations create appreciable differences. For more on the veil created by tears, see Jacques Derrida, *Memoirs of the Blind: The Self-Portrait and Other Ruins* (Chicago: University of Chicago Press, 1993), 122–129.

Afterword
Jesús Vassallo

Within the context of North American architecture and its academic institutions, Michelle JaJa Chang occupies a unique space. On the one hand, she is an inheritor of the preceding generation that instrumentalized difficulty as a method of resistance to market forces, while also using it as a mechanism of exclusion. On the other hand, she belongs to the contemporary generation obsessed with the banal and the boring as an aesthetic proposal, one intended to open up architecture to everyday life.

The earlier generation, of Chang's professors at Harvard Graduate School of Design, privileged the precision of technical drawing, its exacting practice, as a selection mechanism for its membership and a path to gain knowledge of architecture's inner secrets. According to this world view, redundant geometries, or the pyrotechnics of drawings containing multiple projections, all serve the purpose of whipping architecture into a frenzy, of pushing it into a zone where it finally becomes interesting. The current generation believes by contrast that anything can and indeed is interesting if you look at it hard enough. Chang and her contemporaries endorse a closer examination of the built products of late capitalism and marvels at the aesthetic potential of things like two-by-fours and sheetrock.

These two groups differ profoundly in how they internalize the impact of digital technology on the field of architecture, despite the fact that both acknowledge it as the central development of our time. The first group, in command of the discipline during the first wave of digitization around the turn of the century, marshaled its powers toward the taming of increasingly complex geometries and assemblies. The second group, a decade or so later, understood that what is relevant is the pervasiveness of digital technology in every facet of our lives, and how it has

transformed us and the way in which we look at the world. These two positions correspond to distinct moments within the historical process by which a new and extraordinary technology gradually becomes commonplace, but they are also reflective of two seemingly irreconcilable ideologies.

The works and writings of Michelle Chang, loosely collected in this kaleidoscopic book, conform a proposal to move beyond these coarse oppositions. For Chang, current developments in advanced computation offer an opportunity to revisit obscure topics such as shadows, vagueness, or noise, bringing them out of total hermeticism and into a grey zone where they can be discussed as prevalent conditions. In doing so, Chang does not claim ownership of or explicate specific techniques or concepts, but rather shares how they become frameworks for her own marveling at the world.

It is important then that Chang does not hide behind the sometimes-impossible complexity of the topics she discusses: She does not seek authority, nor does she try to completely vanquish their mysteries. Her interest is not in the process of mastering a difficult subject, but rather in the possibility to use a series of concepts to gain greater nuance in examining things and phenomena that sit at the edge of comprehension, regardless of how exotic or familiar they may be.

The idea of wonder is then central to this book, both as the true unifying thread of the many disparate materials and observations that Chang brings to the table, but also as the ethos underlying her creative work. Her interest in technology and computation is in that regard akin to a fascination with childhood. The computer stands here as an alter ego, an entity vested with enhanced powers of perception and analysis but only a nascent, and therefore, malleable conscience. It becomes a lens to look at the world

anew, not to dispel uncertainty, but to provide a more articulate and beguiling view into it. Eventually, this way to observe things through vectors of otherness permeates a reconsideration of the way in which architects represent things and think through problems as they design, an approach that accounts for the fascinating heterodoxy of Chang's drawing practice.

Chang is not a scientist but an artist, and consequently her primary focus is on how these new paradigms and techniques show up in the world, in the work of her peers, and ultimately, in her own. This is an important consideration not because every architect can automatically be considered an artist, but rather because among architects' fraught relationship with the idea of art, Chang's position is singular in her dual commitment to both a model of practice rooted in the visual arts and a deep concern with matters that affect architecture.

Architects' anxious attitude about their discipline's impure status as an applied art has traditionally resolved in two distinct ways. On the one hand, there is the architect who accepts the profession as the craft of designing and constructing buildings for others, resulting in objects that can attain the status of works of art only in cases of extreme excellence and through the validation of third parties. In the master-builder model, the value resides in the built object, with architectural drawings considered as "instruments of service" and only marginally imbued with value.

On the other hand, and ever since the professions of the designer and the contractor became differentiated, there have been architects that have pursued careers through an enhanced exploration of architectural representation and its projective powers. In the paper-architecture model, drafting techniques are traditionally hybridized with abstract art,

resulting in graphic output as an endgame. For the paper architect, representation itself is the work while the activity of building is at best a liability, with buildings being looked down upon as stubbornly normative things.

Chang instead loves buildings precisely because they are normative things, often mundane in their appearance, but most importantly, the embodiment of the processes and protocols that went into their conception, documentation, and construction. The built object and its apparatus of production are inseparable, both in Chang's questioning of the built environment and in her own design work.

Perhaps an interesting precedent for such an attitude would be the early career of British architect Tony Fretton, who as a young man debated between becoming an artist and an architect. Famously, by his own account, he was working on construction sites while saving money for art school when he had the revelation that an art practice could be had that would manage the objects and processes of the job site as its raw matter. After stints as a performance artist and a project architect at a commercial firm, Fretton's very first independent projects truly synthesized the idea that an experimental art approach could be brought to bear into the making of relatively modest buildings.

Chang's approach differs from that of young Fretton, however, in that her interest in buildings' normative qualities is both more explicit and more explicitly geared toward actively throwing those norms into question. Additionally, Chang extends the interest in the built objects of architecture to evenly encompass the workflows required to produce them, which today are thoroughly infiltrated by digital technology. For Chang both the building and the drawing are objects of equal importance, understood at a deep level as manifestations of the same thinking process,

with the design of such process constituting the more authentic expression of the work.

Whether this book will come to be regarded as the preface for a building career for Chang, or whether her work will remain mostly in the space of publications and the gallery will be a matter of both opportunity and preference. Regardless, the commitment to a practice between mediums will remain integral to the work. For Chang, an innate curiosity about different ways of seeing and thinking naturally translates into new ways of drawing, which in turn impacts her making process. In all its phases, this cycle is driven by an urgent search for that magical moment when architecture reveals just enough of its secrets to make us stop and wonder.

Acknowledgments